·IN FOCUS·

KU-112-041

Exhibition researched and organised by

Xanthe Brooke

NATIONAL MUSEUMS & GALLERIES
· ON MERSEYSIDE ·

16 NOVEMBER 1990 · 13 JANUARY 1991
WALKER ART GALLERY · LIVERPOOL

Front Cover *Virgin and Child in Glory* Walker Art Gallery
Detail from *Self-portrait* National Gallery

British Library Cataloguing in Publication Data

Brooke, Xanthe, 1960
Bartolomé Esteban Murillo, Virgin and Child in Glory,
I. Spanish paintings. Murillo, Bartolomé Esteban
II. National Museums and Galleries on Merseyside. Great Britain

ISBN 0 906367 44 1

· C O N T E N T S ·

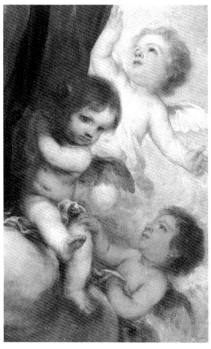

Detail from the
Virgin and Child in Glory by Murillo

· FOREWORD ·

Murillo in Focus is the first in what we hope will be an occasional series of small exhibitions designed to provide visitors with a greater understanding and enjoyment of some of the Walker's outstanding masterpieces.

Murillo is perhaps not an obvious choice for this treatment as today he is unfashionable, and his work is often unfairly dismissed as sentimental and sugary. It is a salutary reminder of the whims of taste that in the 18th and 19th century Murillo was admired as one of the greatest of all painters and that, as this exhibition demonstrates, he was a potent source of inspiration to British artists. At the Manchester Art Treasures exhibition of 1857, which revealed for the first time in public the wealth of Old Masters in British collections, the Spanish section included 26 pictures by Murillo, 23 by Velazquez and 4 Goyas. Today, Goya has risen higher than Murillo in the public estimation, but this does not alter the supremely radiant quality of the Walker's *Virgin and Child in Glory*. Xanthe Brooke, who devised and researched the exhibition, has made an illuminating choice of pictures to demonstrate Murillo's achievement and influence, and to explain the context in which he was working. I would like to express my thanks to her.

I am deeply grateful to Her Majesty the Queen, who has graciously lent to the exhibition, and also to the other lenders: the Duke of Buccleuch; the Duke of Devonshire; the Williams-Wynn Trustees; the Hon. Simon Howard; Christopher Loyd Esq.; the Dulwich Picture Gallery; the Graves Art Gallery; and the National Gallery. I would also like to thank the Granada Foundation for supporting the exhibition.

After undergoing the vicissitudes outlined in the catalogue, the *Virgin and Child in Glory* came to the Walker as a gift from the National Art-Collections Fund. It seems appropriate to close this Foreword with a note of appreciation to the Fund for its generous support in helping us to enrich Liverpool's art collections, for the delight and instruction of our many visitors.

Julian Treuherz, *Keeper of Art Galleries*
National Museums & Galleries on Merseyside

· ACKNOWLEDGEMENTS ·

I should like to express my thanks to the many people in Spain, Britain and the United States who have helped my researches for the exhibition and the historical essay which introduces the catalogue. I am particularly indebted to: Vicente Lleó Canal for his knowledge of Seville's architecture and Enrique Valdivieso for kindly showing me round the Archiepiscopal Palace and for his help in obtaining illustrations; Duncan Kinkead, who shared with me his views on Valdés Leal and his knowledge of Archbishop Spinola's will; and Peter Cherry for his unfailing advice at all times.

I should also like to thank all the lenders, private and public, who have made this exhibition possible, and the Granada Foundation who have supported the exhibition and catalogue with a grant. My thanks also go to all those at the Walker Art Gallery who have helped and supported the exhibition and particularly Julian Treuherz, Edward Morris, David McNeff, Frank Milner and other Education staff and Roy Irlam for his work on the new frame for the Murillo altarpiece. I am also grateful for the assistance I have received from other departments within N.M.G.M.: Conservation, Design and Production, and Commercial Services and Marketing.

Above all I should like to thank Chris Lewis for his constant encouragement and editorial advice.

Xanthe Brooke

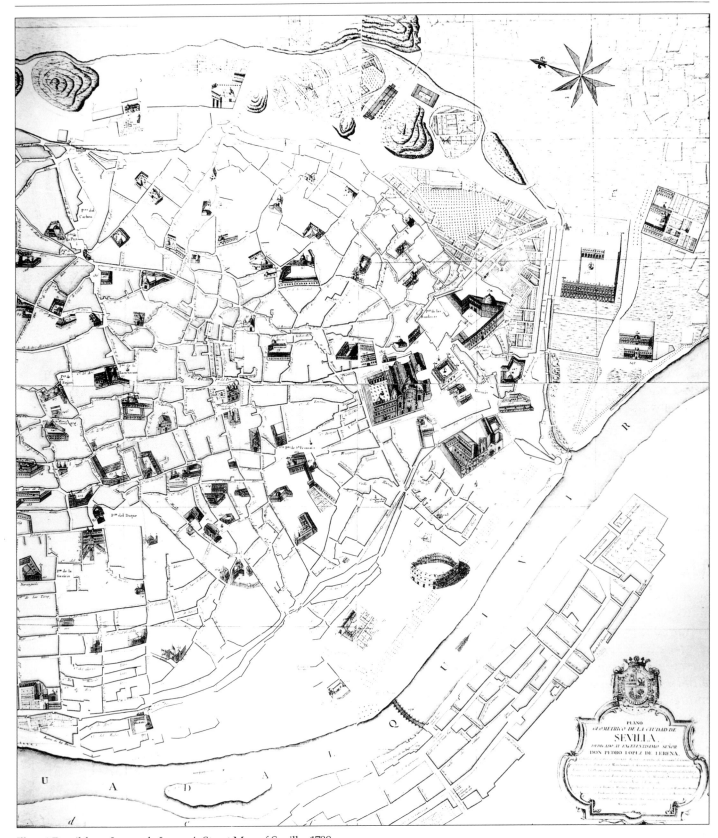

Illus. 1 Detail from Lopez de Lerena's Street Map of Seville, 1788

'His most glorious decade' was how Spain's leading nineteenth-century art historian, Ceán Bermúdez, described Murillo's work of the 1670s. In that decade he produced many of the paintings that gave him international fame, including the Walker Art Gallery's *Virgin and Child in Glory*, painted in 1673 as an altarpiece for Ambrosio Ignacio Spínola y Guzmán, Archbishop of Seville, and one of his most prestigious and important commissions in a decade of success. This essay traces the circumstances of the commission and outlines the social, religious and artistic background which shaped it. It also explores the significance of the painting to a wider public than was originally intended, a public which has included some of Britain's most celebrated artists. The altarpiece's dramatic history and the comments and treatment it has received from artists, collectors, soldiers and bankers from the seventeenth through to the twentieth century do much to highlight British preferences and attitudes towards one of Spain's masterly exponents of painting, Bartolomé Esteban Murillo (1617-82).

Murillo and Seville

By 1670 Murillo, aged 52, was the dominant painter in his native southern city of Seville, making a comfortable living from his commissions and, like several other Sevillian artists, from leasing urban tenements. His parents were solid artisan stock, the father a barber-surgeon (literally a barber of Seville) of enough standing to own a few slaves, the mother from a family of silversmiths and painters. The artist took his mother's family name as was common in Andalucia. He was the youngest child of fourteen and both parents died before he was eleven, leaving him to be raised by one of his elder sisters and to seek his living from his precocious artistic talent. In his teens he began his artistic training under one of his mother's kinsmen, Juan del Castillo. Sudden death, orphaned

families and infant mortality were common features of seventeenth-century Spanish life which affected both rich and poor. The pattern recurred in Murillo's own history when his wife died in 1664, with three sons and a deaf daughter surviving, all under eleven. Murillo remained a widower and brought up his children with the help of the sister who had raised him. Three of the children survived their father but only one could be with him on his death bed, as the daughter had entered a convent and one son had emigrated to South America, as Murillo himself had nearly done when young. The experiences of childhood must often have been in Murillo's mind. His surviving children were precious to him. According to several anecdotes the youngest often accompanied him when he worked. Murillo may have used his own family as models (Cat. No. 9) and painted certain subjects in honour of them. The portrayal of the Dominican nun St. Rosa de Lima (illus 2) in several of his pictures might well have been stimulated by the fact that his daughter adopted her name on entering the Dominican convent of Madre de Dios in 1671. The inscription below his *Self-portrait* (Cat. No. 1), stating that it was painted to fulfil the wishes and prayers of his children, was no platitude.

Throughout his life Murillo was closely identified with his native Seville. Unlike his fellow citizen, Velázquez, he rarely left the city and when he did it was only briefly. His attachment was so great that he was even supposed to have declined a royal request to move to the court in Madrid as Velázquez's successor, and sent a painting instead (Cat. No. 4). Part of his affection for Seville stemmed from his knowledge that he dominated its artistic scene, and from there could overshadow the wider Spanish stage as well. From the age of thirty he had consistently won the major commissions which commanded higher fees from the multitude of religious institutions, clerics and some

merchant families in Seville, enabling him to grow from his provincial base into an artist of international stature in seventeenth-century Europe. Seville also

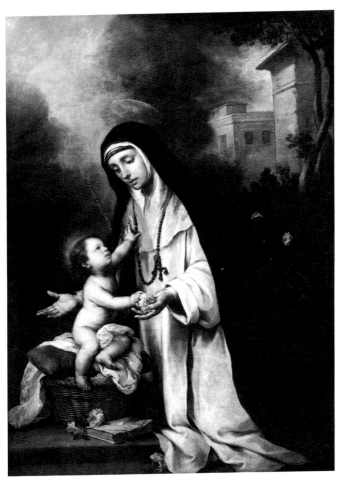

Illus. 2 Murillo *Santa Rosa de Lima*

provided much of his subject matter. His art in turn fed the city's own image of itself as devoted to the Virgin Mary and inhabited by the poor but carefree.

Murillo's Seville was a still-rich commercial city whose trading fortunes had begun to ebb. Its great wealth, based originally on control of trade with the Indies and particularly with the Spanish-owned silver mines in South America, declined rapidly and finally collapsed in the next century. In the second half of the seventeenth-century its history was pockmarked with incidents of drought, famine, riot, earthquake and a disastrous plague in 1649 which may have halved the population to approximately 60,000 inhabitants. To some outsiders it had a bad reputation. St. Teresa of Avila considered that the devil had more power over

Seville than any other city. Others, including Samuel Pepys on a brief visit in 1683, were struck by the extreme respect - almost equality - which was accorded to the vast number of beggars and vagabonds. Murillo himself appears to reflect such non-judgemental social attitudes in his paintings (Cat. No.9). As the historian J. H. Elliott has commented, Seville was above all a city with a strong pride in itself, dedicated to display.[1] Despite the squalor of its streets and the mass of destitute people created by the city's deteriorating trading fortunes there was still a stratum of wealthy individual and corporate patronage which, particularly after the plague, was directed towards the maintenance and decoration of charitable institutions. Private patrons were mainly found in the commercial community who in Seville, as elsewhere in Spain, were predominantly foreigners - Italians, English, Irish and particularly Flemish and Dutch who had recently been subjects of the Spanish Crown. Several merchants from the Low Lands commissioned portraits and religious works from Murillo, and they may have helped him in other ways. One in particular Nicolas Omazur, became a good friend and had a distinguished art collection including works by Van Dyck and copies of Rubens paintings, artists who influenced Murillo's developed style as seen in the *Virgin and Child in Glory*.

Murillo's regular income came from the patronage of the all-pervasive Church, its clergy, the many lay brotherhoods and especially from the Cathedral and its authorities. The city's 150 or so monasteries, convents, friaries, seminaries and parish churches were not uniformly rich. Some like the Capuchins, bound by vows of poverty, could retain Murillo for their chapel only because he offered his services free. The Cathedral and Archbishopric of Seville, however, was one of the wealthiest in Spain. Religious institutions, therefore, provided most of the major commissions for Sevillian artists. Other painters besides Murillo made a living, particularly if they could diversify into other activities such as engraving or designing structures for religious festivities, as did Murillo's younger contemporary, Juan de Valdés Leal (1622-90). Valdés Leal cornered the market in multi-canvas commissions for religious institutions through his ability to work quickly, economically and on a large scale. Both Murillo and Valdés Leal held official posts in Seville's Academy of Art, founded in 1660 by

Murillo and a fellow painter, Herrera the Younger, as an official association of the city's artists and a training institution for students and foreign painters. Murillo was the first president, and Valdés Leal was elected to the post three years later. Despite dramatically different styles and painting techniques and their supposed personal antagonism they worked alongside each other at least twice. The second occasion was on the private chapel in the Archbishop's Palace from which the Walker Art Gallery's painting came. The relationship between the two artists and the remarkably different work they produced for the Archbishop - the most prestigious patron either had ever had - will be examined later.

Murillo and Spanish Counter-Reformation Art

Murillo was Spain's foremost painter of sacred art, but his work was more than just a faithful reflection of the religious fervour of the Catholic Church in his time. His versions of some sacred themes have since become objects of devotion throughout the Catholic world, presenting archetypal images of human and divine love through visions of the Virgin and Child, the Holy Family, the Infant St. John the Baptist, the Christ Child as the Good Shepherd and above all the Virgin's Immaculate Conception. Murillo's compositions for all those themes have been reproduced incessantly over the last two centuries in oils or in print, providing the images as diverse as copied paintings for parish churches, seminaries and Church schools to devotional postcards and souvenirs, in England as much as in Spain. Although Murillo's work encapsulated the objectives of Spanish religious art at the end of the seventeenth century, his success in subsequent centuries is due to his ability to interpret and reformulate the religious sensibility of his time. The seventeenth-century Catholic Church pursued a Counter-Reformation policy attacking the Protestant Reformation by encouraging artists to treat sacred themes in a manner more familiar and accessible to the general public without straying too far into the purely anecdotal. In Flanders and Italy masters such as Rubens (1577-1640) and Reni (1575-1642) depicted the Holy Family engaged in everyday activities. Both artists had a major influence on Murillo through originals, painted copies and prints. Reni created and

promoted by the 1620s the theme of the *Christ Child asleep on the Cross*, (illus 3) focussing on the tender depiction of Christ as a sleeping child, a crucial image which Murillo later made his own (Cat. No. 3). Murillo's domesticization of sacred scenes accorded with the mentality of the time, encompassing Protestant as well as Catholic Europe, as for instance exemplified in any Rembrandt *Holy Family*.

Within Counter-Reformation Europe, the Habsburg rulers of Spain saw themselves as the guardians of a Catholic faith to be defended with armies and promoted through missionary orders. Spain's leading role in Catholic Europe was also reflected in a peculiarly strong popular piety which in turn gave a

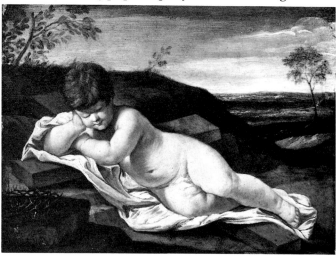

Illus. 3 Studio of Reni *The Infant Christ Asleep on the Cross*

particular iconographic slant to its religious art. The Immaculate Conception of the Virgin - the belief that the Virgin had been born exempt from any trace of Original Sin - was one such theme closely associated with Murillo, the artist who popularized it and ultimately produced its standard representation. Spanish political pressure lay behind the original papal injunction of 1616 against those who doubted the Virgin's Immaculate Conception and the papal brief of 1662 affirming belief in it. Spain's political masters had been persuaded by the Franciscans and Jesuits in the face of opposition from the Dominicans who controlled the Spanish Inquisition. Elsewhere in Catholic Europe the cult of the Immaculate Conception was controversial and it was not pronounced a dogma, a mandatory belief for all those acknowledging Rome's spiritual authority, until 1854.

Both seventeenth-century papal declarations resulted in public rejoicing throughout Spain but nowhere more than in Seville, a city renowned for its devotion to Mary and where there had been demonstrations in the streets in favour of the doctrine for several years before its approval by the Pope. Murillo's vision of the Immaculate Conception (illus 4) as a young adolescent girl dressed in the purest white and blue, and standing on a sliver of a moon lifted heavenwards by a host of playful cherubs became the archetypal image of a complex and abstract theological concept. Earlier doctrinally correct depictions followed the rulings of the Inquisition, as transmitted by its artist-adviser, the Sevillian Francisco Pacheco. They showed a statuesque Virgin surrounded by as many Marian symbols culled from the Bible as was possible as for example in Zurbarán's painting dated to around 1630-35 (Prado, Madrid). Murillo's young girl, however, personified in herself the idea of the Immaculate Virgin. She had little need of emblems other than the moon and occasionally a rose, lily or palm leaf. The Virgin was not intended as a mere symbolic representation of the concept but as the concept itself, embodied in a tenderly emotive vision acceptable to the faithful. As with most of Murillo's visionary paintings it aimed to convince those contemplating it of the love of the Holy Person towards them. Her outward beauty predisposed the

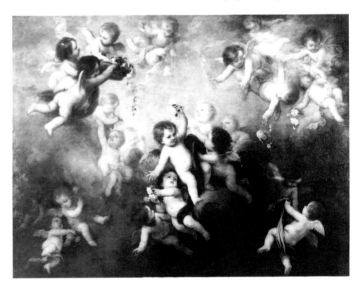

Illus.5 Murillo *Cherubs Scattering Flowers*

devout to venerate her and the mystery of the Church she represented, whilst the recognizable humanity of the putti made the spiritual image accessible on a more familiar level. Murillo's interpretation of the Immaculate Conception with its multitude of cherubs did much to spread his fame. In 1729 when John, 1st Viscount Perceval, saw some of the earliest works to enter England by a 'little known' Spanish artist whom he referred to as 'Monglio' he wrote that 'he was fond of painting cupids'.[2] One of the paintings he may have been inspecting, along with the artist's *Self-portrait* (Cat. No. 1), was a very large canvas devoted entirely to cherubs (illus. 5) but possibly intended to accompany a sculpted Immaculate Conception.

Several other themes relating to children were taken up by Murillo with greater constancy than any other Spanish artist. The youthful St. Joseph leading or holding the Christ Child, the Child Christ as the Good Shepherd, and the infants Christ and St. John the Baptist playing together were subjects newly introduced to Spain in the late sixteenth and

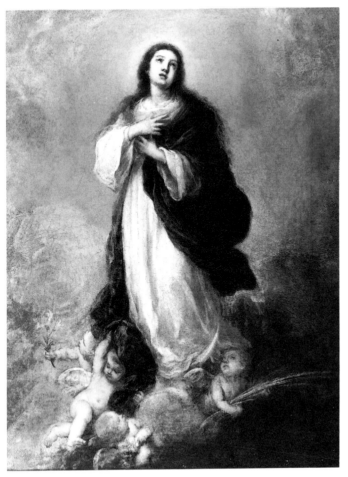

Illus.4 Murillo *The Immaculate Conception*

the Dominican nun St. Rosa de Lima (illus 2) in seventeenth century, in line with Counter-Reformation ideals or as a reflection of forms of piety prevalent in Spanish religious houses. They were especially associated with the Carmelite Order, recently reformed under St. Theresa of Avila, whose patron was St. Joseph and in whose convents images of Christ and St. John the Baptist as children were and still are particularly popular. Murillo's conception of these themes had a pervasive influence on all subsequent representations. Apart from their religious content, his paintings were consummate depictions of childhood and his habitual introduction into religious narrative pictures of anecdotal scenes involving children suggest his deep-rooted fondness for subjects drawn from childhood. Indeed Murillo's reputedly favourite painting, *St. Thomas of Villanueva*, combines many key themes dear to the artist: the central figures of a compassionate saint surrounded by pitiful beggars and sick children are balanced in the foreground by a mother and her child delighted by the saint's charity. Furthermore, Murillo's secular genre painting consists almost entirely of subjects relating to children. His soft-focus style of painting skin with pink and brown flesh tones melting gently into each other lent itself to producing masterly portraits of children, which were appreciated by his market.

The Painting in Focus:
The `Virgin and Child in Glory´ and its patron

In the absence of a royal court in Seville the wealthiest and most prestigious source of individual artistic patronage was its archbishop. Ambrosio Ignacio Spínola y Guzmán was formally installed in the see in 1670, aged 38, retaining it until his death in 1684 two years after Murillo's own. As befitted one of the richest archbishoprics in the country Spínola was the second son of one of Spain's wealthiest and most eminent families, with close links to the court, and had spent his early childhood, after his mother's death, as the page and playmate of the heir to the throne, Baltasar Carlos. His maternal grandfather and namesake, the Genoese General Ambrogio Spínola, was the victorious leader of the Spanish troops in the

Netherlands whom Velázquez immortalized in his painting of the General receiving the surrender of the Dutch forces at Breda in 1625. His uncle was a Cardinal and former archbishop of Seville, in whose household Spínola had lived for some six years and beside whom he was eventually buried in the city's Jesuit church. His father, the Marques of Leganés, was a favourite of the King's minister, Count-Duke Olivares, a councillor of State and a general with service in the Netherlands and Italy (illus. 6). Leganés's wealth and service abroad gave him both the means and the opportunity to become one of Spain's leading collectors. On his death in 1655 he owned the largest private art collection in Spain, comprising some 1,300 works including pictures by Titian, Veronese, Raphael and many Flemish paintings, as well as works by Rubens

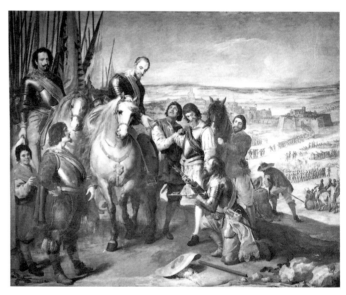

Illus.6 Juseppe Leonardo *Surrender of Julich*. Showing both the Marques of Leganés and General Spínola on horseback, the Marques to the left and the General in the centre.

and a portrait of his wife, Policena Spínola, by Van Dyck. Some of the collection may have descended to Archbishop Spínola. Certainly the Archbishop's own will included a Van Dyck portrait of his father as well as religious works by Titian, Bassano and Cigoli.[3]

In his own lifetime Spínola was lauded less for his art collection and patronage, which was never mentioned in the lengthy eulogistic biography published on his death, than for his practical charity and abundant almsgiving. His biography, referring to him as the 'father of the poor', records how he gave alms to

hundreds at his Palace gate every morning and personally served a meal every Thursday in the Palace courtyard to thirteen honoured poor.[4] In years of famine the gift of money was augmented with a dole of bread paid for by the sale of his jewels. The Church as a whole was the main provider of health and social security to the city's destitute and sick. Archbishop Spínola made himself an active head, subsidizing hospitals out of his own pocket and often dropping in without warning to check on their efficient administration and the welfare of the sick. He was venerated almost as a saint by many who had heard of his charitable acts and especially the manner of his death, caused by his ceaseless praying in a downpour for the deliverance of his city from floods. His biographer took pains to deny that any of the pious acts mentioned were those of a saint.

Despite the lack of contemporary written evidence, Spínola is known to have spent money on artistic concerns. The Archbishop's Palace was not the impressive building one might have expected, though his predecessor, Antonio Paino (1663-9), had begun to rebuild and extend it. Spínola did much to adorn the newly built but as yet undecorated rooms. The silence in contemporary literature regarding his artistic patronage may well have been judicious. Paino was abused and insulted in the streets by inhabitants critical of his expenditure on his palace, despite his defence that it provided jobs. Spínola's youth spent amongst his family collections and his status in Seville must have predisposed and stimulated him to approach the best once he had decided to embellish his private chapel.

By the time that Spínola, an active mature man with several bishoprics behind him, arrived in Seville in 1670, Murillo had already enjoyed close relations with the Cathedral chapter, working for the Cathedral and individual canons, several of whom were his friends. As the city's outstanding painter, Murillo was the obvious choice for any major commission. His earliest work for the archbishop may have been as a portraitist. Spínola's will mentions a Murillo portrait of his nephew, the 2nd Marques of Leganés, and an entry in an inventory made in 1687 for a Seville nobleman, the Duke of Moscoso, suggests that Murillo may have been engaged to paint Spínola's portrait as well. The only portrait of Spínola now known was one painted about

1670 by one of Murillo's closest followers, Pedro Nuñez de Villavicencio (illus. 7). The nickname of the 'Spínola Madonna' appended to another Murillo, the *Virgin and Child* in Dresden, could also indicate an original association with the Archbishop if it is not a romantic nineteenth-century epithet. These are all unproven possibilities as works by Murillo for Spínola. What is certain is that in 1673 the Archbishop engaged Murillo to paint the *Virgin and Child in Glory* for the altarpiece of the lower oratory in his palace. Spínola thought so

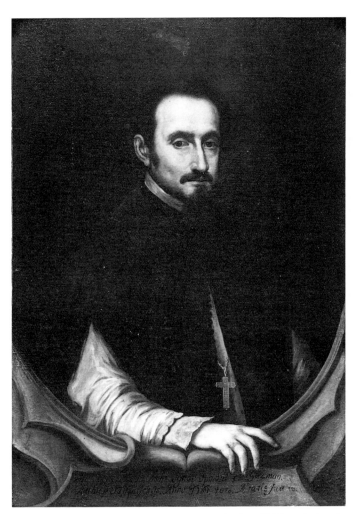

Illus.7 Pedo Nūnez de Villavicencio *Portrait of Archbishop Ambrosio Ignacio Spínola y Guzmán*

highly of the painting, along with a series of seven canvases by Valdés Leal detailing the *Life of St. Ambrose* commissioned at the same time, that he stipulated in his will that they should 'remain where they now were' so that they 'should always serve to adorn the

Archbishop's house' ('se quede todo puesto en las partes donde hoy estan que sirviessen siempre para adornos de estas casas arzobispales').[5] Spínola may indeed have done more than commission the painting. He could also have helped shape its unusual iconography, rare amongst Murillo's work.

The Painting in Focus:
The Iconography

Even in a country devoted to the Virgin Mary, Archbishop Spínola was more fervently devoted than most. His biographer recounts how from the age of fifteen, wherever he was, he would pray twice daily in an oratory whose principal adornment was a painting of the Virgin. When ill, he prayed to her from his sick bed, presumably with the aid of the half-length painting of the *Virgin suckling the Christ Child* which according to his will he always carried with him. He also owned a reliquary sculpture of the Immaculate Conception by Seville's leading sculptor Pedro Roldán. Both his will and biography show he was particularly devoted to certain images of the Virgin as 'Queen of the Angels'.[6] His earliest attachment was to the Jesuit Virgen de la Estrella, to whose chapels in Seville Cathedral and the Jesuit collegiate church in which he was buried he donated ornaments and silver. The Jesuits' guide and patroness, the Virgen de la Luz, was portrayed in the eighteenth century as surrounded by angels and more resplendent than the sun.

But there were two other images in the Cathedral to which Spinola showed particular adherence, at whose altars he prayed during the ceremony of his first entering the Cathedral and before which he continued to pray on most days until his death. Both pictures, Nuestra Señora de los Remedios and the Virgen de la Antigua, were ancient images, fourteenth- and fifteenth-century paintings showing the Virgin in typically Gothic stance silhouetted against a golden ground, in the one case putting her Child to her breast and in the other standing holding Him tenderly in her arms (illus. 8). The Virgen de la Antigua had the largest side chapel in the Cathedral and was prayed to in times of natural disaster and danger.

The reverence shown by Spínola to this ancient image

is significant as it may help explain the unusual composition chosen by Murillo. Throughout his career Murillo painted many types of madonna, some representing theological concepts or narrating episodes from her life, others shown with symbolic attributes linking them to specific religious orders, but in no other known painting by the artist does the

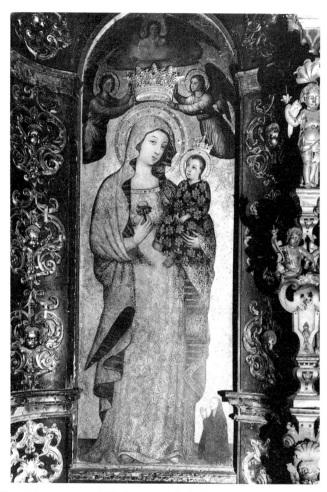

Illus.8 Anonymous 15th Century *Virgin de la Antigua,* Seville Cathedral

Virgin appear standing holding her Child against a luminous golden aureole of cloud. The Walker's altarpiece bears a much closer resemblance to the traditional depiction of the Virgin and Child as the Queen of Heaven than to any of the 'correct' images suggested by contemporary religious authorities. When Murillo chose to paint Mary and her Child in glory they usually appear seated on a throne of clouds invariably accompanied by a host of saints, or less commonly seated alone as a devotional image for a

particular Order such as the Dulwich Gallery's Dominican *Madonna of the Rosary* (Cat. No. 8).

The only heavenly images in which the Virgin normally stands were those of her Assumption and those celebrating her Immaculate Conception, both of which traditionally showed her alone without the baby Jesus in her arms. Spain's foremost interpreter of orthodox religious opinion on sacred imagery was Pacheco, whose treatise *Arte de la Pintura* offered prescriptive guidance to artists on approved iconography. In Pacheco's opinion the Virgin on her Assumption should be accompanied only by angels and a martyr's palm. As the Immaculate Conception she should be shown as a young girl dressed in blue and white and 'clothed in the sun' standing on the moon, sometimes trampling on the dragon of evil but accompanied only by angels. Pacheco, whose writings were based on theories and practices current in the early part of the seventeenth century, preferred artists to show the Immaculate Conception as a young girl alone because this was how she was described by the Franciscan Order, the doctrine's oldest defender. At the same time, however, he was aware that some still preferred the older image of the Conception as a Virgin holding the Child Jesus in her arms. In Pacheco's time the newer Franciscan image was already the most widespread in Spain, and by 1673, when the *Virgin and Child in Glory* was painted, an Immaculate Conception with a child, no Marian attributes at all and clothed in the 'wrong' colours, deep blue and red instead of blue and white, would not have been contemplated, least of all by Murillo who had created its standard image.

The Walker's altarpiece bears instead some resemblance to the medieval representations, referred to by Pacheco, of the Virgin as Queen of Heaven, which usually show her with her Child, wearing a red tunic and blue mantle, both looking out at us, her head a little to one side and his hand raised in greeting or blessing. The fourteenth-century Virgen de la Antigua in Seville Cathedral, one of Spínola's preferred paintings, was just such an image. The picture was wrongly believed to be a miraculous survivor of Muslim control, hidden behind a wall of the city's Great Mosque and rediscovered after the reconquest by Ferdinand III of Castile in 1248. In 1671 Ferdinand was made a saint, to great rejoicing in the

city and Cathedral. Religious celebrations continued into the next year and coincided with a major ceremony held in the Cathedral in which Spínola baptized forty-three Muslim North African and Turkish slaves into the Catholic faith. As an image the Virgin was intimately related both to Ferdinand III and the Church's propagation. According to the city's chronicle the Virgin appears to have been particularly honoured in 1672-3, the year in which Murillo would have been working on Spínola's altarpiece. Murillo had already painted a work for the Antigua Chapel's own sacristy in the 1660s. It may be, therefore, that the altarpiece Murillo produced for Spínola was conceived as a 'modernized' version of a traditional Marian theme close to Spínola's heart.

The Painting in Focus: *The Archbishop's Private Chapel*

Murillo's altarpiece was painted for and hung for over a hundred years in a chapel always referred to as the lower oratory of the Archbishop's Palace, in the city centre just across from the Cathedral. (Illus. 9). The lower oratory was swept away many years ago when the ground floor rooms of its wing were rebuilt for accommodation. Probably due to its private

Illus.9 Inner Courtyards of the Archbishop's Palace, Seville

function, it was not known, described or illustrated by any of the Spanish or foreign visitors to the Palace from the seventeenth to the nineteenth century. However, it is still possible to visualize the original placing of the chapel and to understand the significance of its position. The courtyard off which

the oratory chapel stood was meant to provide shade and coolness at the heart of the remodelled Palace. Around it were arranged, on the upper floor reached by a grand staircase, the main ceremonial and official apartments, such as the 'salon principal' where all public functions were held; and on the ground floor the Archbishop's private suite of rooms. The lower oratory on the ground floor, housing the altarpiece, was not, therefore, part of the state rooms but of the archbishop's private apartment, which probably accounts for the lack of travellers' accounts. Because of its private function, the chapel and the Murillo altarpiece would have featured prominently in Spínola's daily life. In 1684 his biographer described how his daily routine was to pray, with his pages in the morning and with his servants in the evening after his siesta, at both times in the oratory which he had specially dedicated to the Virgin Mary, placing a painting of her as 'its principal adornment'. The image of the Virgin was, therefore, intended as one of very great personal significance for Spínola; when the cares of the world weighed him down, he used to retire to his oratory to seek private solace with God. The painting we now see in the Gallery was intended by Murillo to be an intimate vision in which the Holy Mother and her Child appeared for the archbishop alone to contemplate as he prayed in the choir of the oratory, offering him consolation, a grander, more monumental but still tender version of the many images of the Virgin which he carried with him and surrounded himself with in his palatial apartments.

The Painting in Focus:
Murillo and Valdés Leal

Murillo's *Virgin and Child in Glory* was not the only painting decorating Spínola's private chapel. In the same year, almost certainly at the same time, he commissioned from Valdés Leal, Murillo's Seville Academy colleague, a series of seven canvases illustrating the *Life of St. Ambrose: The Miracle of the Bees; St. Ambrose pronounced governor of Milan; St. Ambrose consecrated bishop of Milan; The conversion and baptism of St. Augustine by St. Ambrose; St. Ambrose refusing Emperor Theodosius entrance to his Church; St. Ambrose absolving Emperor Theodosius;* and *The last communion of St. Ambrose.* The date of 1673 for both these prestigious commissions can be inferred from

Murillo's and Valdés Leal's known activities around that time and particularly from the documentary evidence formerly in the Palace archives, for the payment of 1,000 ducats to Murillo for his one canvas and 10,000 ducats to Valdés Leal for the series of seven oil paintings and also for his work on the gilding and decoration of the whole altarpiece. In October 1673 Valdés Leal signed another contract for gilding an altarpiece, by which time one must assume that his work on the Archbishop's commission had come to an end. The gilding and decoration (*estofado*) of altarpieces was a crucial factor in the success of Valdés Leal's workshop in a city whose lucrative commissions were dominated by Murillo.

As was normal in Seville and elsewhere in Spain, the altarpiece frame would have been richly decorated to enhance its overall effect. Murillo's painting would have been set into a large, carved, gilded and painted construction to form the altarpiece, which itself could accommodate other paintings, or more usually in Seville sculpted and painted figures. As it was common in Seville to mix paintings and sculptures in one altarpiece, it is quite feasible that one possible arrangement of the paintings would have been to have the Valdés Leal series set out around a central sculptured image and the Murillo painting in its own altarpiece.[7] However, the only reference we have to the lower oratory mentions only one altar.[8] This evidence, combined with Spínola's almost lifelong habit of dedicating his personal chapel to the Virgin Mary, makes it more likely that the altarpiece resembled the photographic reconstruction suggested here (illus. 10), with Murillo's *Virgin and Child in Glory* in the central niche surrounded by Valdés Leal's narrative of the *Life of St. Ambrose.* The combination of more than one painter's work in the same altar was not considered unusual.

Moreover the amalgamation of the two artistic themes had a special significance for Archbishop Spínola. The St. Ambrose series honoured the fourth-century Bishop of Milan, one of the four great Doctors of the Christian Church and one of the earliest to maintain the Virgin Mary's freedom from sin. Several members of the Spínola family had held the governorship of the city of Milan, whose patron saint was St. Ambrose. In addition, the saint was Archbishop Spínola's namesake, and he was consistently compared with

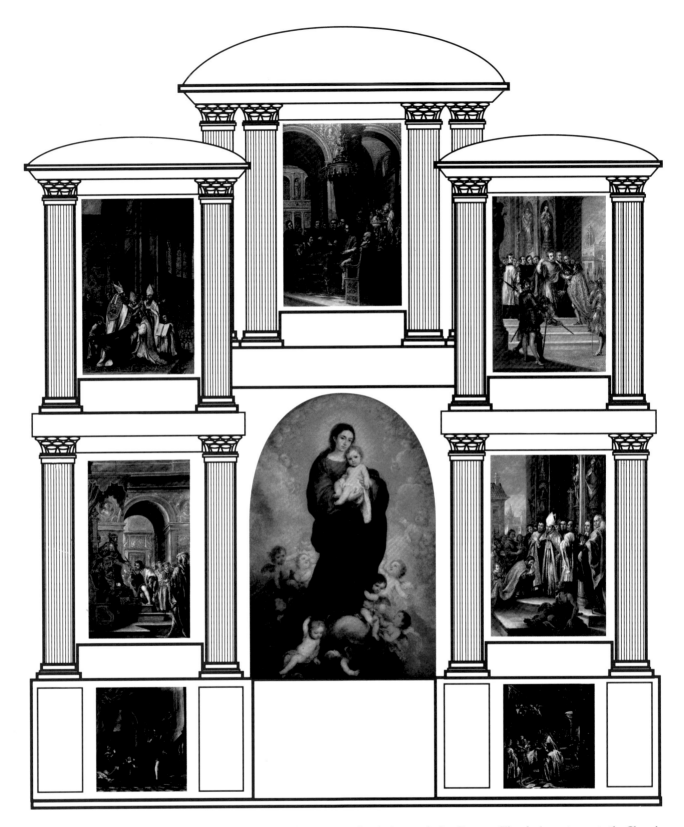

Illus. 10 Reconstruction of the Spinola altarpiece. From the lower left clockwise:
Valdés Leal *The Miracle of the Bees; St. Ambrose pronounced Governor of Milan; St. Ambrose consecrated bishop of Milan; The Conversion and Baptism of St. Augustine by St. Ambrose; St. Ambrose refusing Emporer Theodosius entrance to the Church; St. Ambrose absolving Emporer Theodosius; The Last Communion of Ambrose*
In the centre
Murillo *Virgin and Child in Glory*

him throughout his clerical career. In Seville Spínola was referred to as the 'new St. Ambrose' for his zealous opposition to theatrical performances in the city and his evangelical promotion of Catholicism over other faiths. Within the Church, St. Ambrose was considered a perfect Christian bishop on whom others should model themselves. As one of the earliest leaders of the Church to maintain that the Virgin was imbued with a special grace and to elevate her to a pre-eminent position among the saints, his life was an apposite theme to combine with Murillo's image. The implied parallel in Valdés Leal's series between St. Ambrose and Spínola, Milan and Seville, is further strengthened by the Saint's facial features, which are reminiscent of a youthful Spínola. Several other of the clerics depicted could also be portraits of contemporary Sevillian citizens, whilst some of the striking architectural backgrounds appear based (with some imaginative variations) on Seville Cathedral and the staircase of the Archbishop's Palace.

The altarpiece must have made a startling impact once it had been completed, for although it was not uncommon to incorporate the work of two artists into one reredos, in this case both artists worked in distinctly different styles. We have a first-hand account of Valdés Leal's frenetic manner of working from a fellow painter and art theorist, Antonio Palomino, who as a young man had visited his studio in 1672, only a year before he set to work on Spínola's commission. He described how Valdés Leal usually stood to paint: 'he liked to step back every once in a while and return quickly to put down a few strokes and then step back again; and that was his usual manner of painting, on account of the restlessness and liveliness of his native temperament'.[9] The nervous, agitated, flickering quality of the paint surface evident in the St. Ambrose series perhaps reflects the energy and exuberance with which he worked. These painterly characteristics, accompanied by the intense emphatic gestures and exaggerated poses that he commonly used, set against gloomy backgrounds enlivened by areas of vivid, saturated colour, come as a contrast to the calm composure, reticent expression of emotion, and harmonious colouring typical of Murillo's religious paintings. It may be that the unusually deep hues of the reds and

blues used by Murillo in the Spínola altarpiece, which create such a strongly defined statuesque outline for the Virgin, were his response to Valdés Leal's colour tones.

According to contemporary and later sources differences in style were not the only things to separate the two artists. Many later biographers, particularly nineteenth-century ones, dwelt on the personal animosities and professional antagonisms which arose between them, allegedly because of Valdés Leal's arrogance and dislike of competition. They particularly delighted in telling one amusing comment passed by Murillo on Valdés Leal's paintings of *Las Postrimerias (The Last Things)* for the Caridad chapel, which with stark realism depicted the skeletons and maggot-ridden bodies of the rich and powerful. Murillo is supposed to have told Valdés Leal, 'Colleague, one has to view these with your hand over your nose'. Though the animosities were probably exaggerated such reports must have had a grain of truth in them. Valdés Leal did not suffer fools or mediocre talent gladly and Murillo appears to have been the main critic of his high-handedness with other artists. One may wonder then why Archbishop Spínola chose such disparate characters to work together on such a personally important commission.

In the years immediately before the archbishop's commission the two artists had been asked to work alongside each other by another patron, Don Miguel de Mañara, whose youthful licentiousness and subsequent repentance made him the prototype for that legendary invention, Don Juan. The wealthy Mañara, from a leading Sevillian family, lived in Murillo's neighbourhood on the eastern outskirts of the city, a widower like the artist and godfather to two of his children. Both Murillo and Valdés Leal were recently inducted members of the Brotherhood of Charity whose chapel Mañara wished the artists to decorate. Had the nineteenth-century legend of the gentle, kind Murillo suffering continually from the intrigues of Valdés Leal been true it is doubtful that they could have worked successfully on two such major projects in succession. The Caridad commission paralleled Spínola's in prestige and in the manner in which both artists' talents were put to use. It thus provides some clues to the reason behind

Spínola's wish to use them. The Brotherhood of the Caridad was predominantly formed of the rich and aristocratic who were pledged to perform acts of mercy such as the care of those found dead and dying on the streets of Seville and the feeding of the homeless and hungry. The Brotherhood and its institutions, a chapel and hospital, had recently been revived by Mañara to become the centre of Seville's charitable life. The commission had, therefore, been a prominent one and the series of paintings produced for it by the two artists were specifically intended by Mañara to enjoin the brothers to their pious activities. The religious themes were divided up between the painters according to their differing styles and artistic temperaments. Thus the allegorical images whose contemplation was meant to enforce the message of Death's triumph even over the rich and powerful were painted by Valdés Leal whilst those scenes in the iconographical programme with a more hopeful message of salvation through works of mercy were offered to Murillo.

It was a common practice in Spain for the Church to give major artistic commissions such as choir-stalls or altarpieces to pairs or groups of artists. The very nature of the large-scale Spanish altars, often reaching the height of the nave, necessitated the employment of a number of artists and craftsmen. But this method was also a way of promoting informal competition between artists to produce high quality work. By the early 1670s contemporary chroniclers were referring to Murillo and Valdés Leal as the 'maestros' of painting.[10] As both were leading Cathedral Chapter artists, each employed for his particular skills, they were the obvious choice for Spínola, who utilized their respective strengths to the full. Although Murillo had begun his career successfully painting saints' lives for cloisters and churches he had restricted such work by the 1670s, whilst for Valdés Leal such multi-canvas assignments formed the staple of his workshop. Throughout his life Murillo was rarely called upon to portray a death such as that of St. Ambrose, favouring instead life as experienced by women and children and visionary scenes as against historical narrative. It was particularly apt that the tender emotive vision of the *Virgin and Child in Glory* was offered to Murillo whilst the dramatic narrative of the life of a fourth-century Bishop in which imposing

architectural views were required and different male types predominated was asked of Valdés Leal. For some hundred years the restrained mellow beauty of the Murillo painting continued to be accompanied by the theatrical gestures of the Valdés Leal series just as Archbishop Spínola had commanded in his will.

The Later History of the *Virgin and Child in Glory:*

(1) Recognition and Subterfuge

By the time of his death in 1682 Murillo's name as an artist worth noting had been established well beyond the frontiers of his country. The German writer on art, Sandrart, included an entry on him as the only Spanish artist in his art dictionary published in 1683 and illustrated a wildly inaccurate biography with a print engraved in Brussels from the artist's *Self-portrait* (Cat. No. 1). In England Murillo was much better known amongst the cultivated elite who knew about painting than his compatriot Velázquez. By 1659 Sir Ralph Bankes of Kingston Lacy, Dorset, owned what is now known to be a copy of a Murillo, whilst in 1693 Lord Godolphin, the Chancellor of the Exchequer, purchased another genre painting of Beggar Boys which had been imported into the country earlier by a former envoy to Madrid with family links to the Spanish nobility. As well as diplomatic channels, close commercial ties with southern Spain ensured that amongst European countries England was particularly well informed about art in Seville. Spain, however, or rather the royal court in Madrid, was somewhat slower to appreciate Murillo's talents. Although notice of the great fame which he enjoyed in Seville had reached Madrid in his lifetime, his paintings did not begin to enter the royal collections until early in the eighteenth century. In 1724 the first biographical dictionary of Spanish artists, with an extensive entry on Murillo, was published by Antonio Palomino.

Of greater importance to the artist's growing reputation was the court's temporary move from Madrid to Seville, where it remained between 1729 and 1733. The prolonged stay opened the eyes of the royal family and their accompanying retinue of

courtiers, diplomats and aristocrats to Seville's art and that of Murillo in particular. From this time onwards his paintings started leaving the city in substantial numbers. The Queen, Isabel Farnese, acquired several pictures (today in the Prado) and when she was unable to purchase what she wanted she commissioned a follower of Murillo's, Alonso Miguel Tobar, to copy them. By 1746 the royal inventories mentioned seventeen works supposedly by Murillo. Significantly in the light of the history of the Spínola altarpiece, part of which was itself copied, the practice of copying continued throughout the eighteenth century and into the nineteenth. In 1770 Matthew Pilkington, an Irish clergyman, noted in his *Dictionary of Painters* that many Murillo copies on the market were being passed off as originals. In 1779 a French painter, Charles Desjardins, offered his copies to the monks of San Francisco in Seville in return for the originals of one of the most admired cloister series by Murillo. Later, Charles IV of Spain urged a similar proposition on the Brotherhood of the Caridad with an equal lack of success.

The court's transfer to Seville must also have done much to boost the interest of the attached British diplomats. It is revealing that some of the earliest Murillos to reach England, such as the Duke of Devonshire's *Holy Family* (Cat. No. 2) and the similarly entitled painting owned by the Duke of Rutland, were imported shortly after the court's stay in Seville when the Spanish government was following a pro-British trade policy. The pressure of demand eventually became so great that in 1779 a royal edict was issued forbidding the export of all Spanish art from Spain. As the accompanying gloss made clear, the decree was meant specifically to protect Murillo's work and was aimed primarily at British dealers, who reacted with suitable outrage at this denial of free trade. Ironically, in the case of the Spínola altarpiece the edict came too late and probably ensured only that even greater subterfuge was used in its disposal than would have been the case earlier.

By 1780 according to an entry on the Archbishop's Palace in Antonio Ponz's *Viage de España*, the first detailed description of Spain's artistic and historic wealth, the painting which he referred to as a Murillo

Conception in the Oratory had already been cut up, half of the Virgin's figure removed and replaced with a copy 'some years back' whilst it was in the hands of a restorer[11]. Ponz further complained of a 'plague of unhappy retouchings' on many other paintings in the Palace. In 1776 the newly installed Archbishop, Francisco Javier Delgado y Vanegas, launched a redecoration scheme for the Palace and Cathedral choir. Between 1777 and 1781 Juan de Espinal was commissioned to paint a series of canvases for the ceremonial staircase and the 'salon principal' in a Murillesque style and to make copies of two Murillo paintings for the Palace. As Director of Painting Studies in Seville's Real Academia y Escuela de Bellas Artes, Espinal had drawn up memoranda on the city's artistic treasures for Ponz to use and was therefore in a position to advise him on what had befallen the Murillo altarpiece. The guilty party was not named by Ponz nor in Ceán Bermúdez's later, more diligently written *Dictionary of Spanish Artists*, published in 1800. He merely added that the mutilation had occurred whilst the archbishop's see was vacant. By the end of the nineteenth century the story had become garbled into a dramatic burglary. But one Spanish historian did refer to the restorer and named him as Pedro del Pozo.[12] From 1772 until his death aged 77 in 1785 Pozo was the Director of Studies at the Real Academia, a relatively recent re-establishment of Murillo's 1660 Academy. It prided itself on its links to Murillo and promoted the study of his work, particularly by encouraging its students to copy and restore his paintings. It would seem quite likely, therefore, that when Archbishop Delgado sought to have one of the most prized paintings in his Palace cleaned and restored he should have turned to the director of the Academy. The ease with which part of the painting was removed and a copy substituted must have been aided by Delgado's absence from Seville for almost the whole period of his archepiscopate, 1776-81. In the year following his appointment Delgado was created Patriarch of the Indies and had to move to the court in Madrid from where he attempted to supervise his archbishopric through temporary ministers.

What happened to the section of painting showing the Virgin holding her Child (illus. 11) between its removal and its reappearance in a retired London

merchant's collection in the early years of the next century is not known. It could have been sold almost immediately to one of the many willing buyers amongst Seville's foreign community. Or it might have remained in the Academy, which was housed in the royal palace, the Alcazar. The latter possibility would have accorded with the general mood of artistic enlightenment in Spain at the end of the eighteenth century, which favoured gathering works together and increasing their accessibility to artists and students. If this were so, the fragment could have

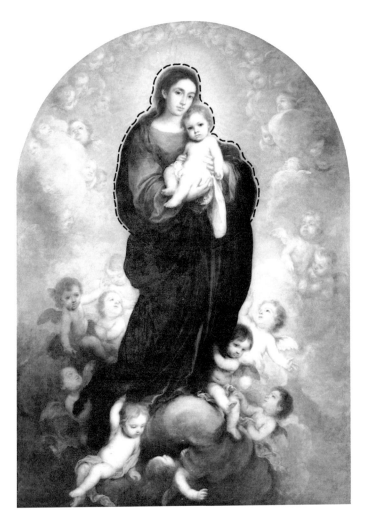

Illus.11 Murillo *Virgin and Child in Glory.* Showing the section removed from the altarpiece.

remained there until April 1807 when the Academy's patron, Francisco de Bruna y Ahumada, died without issue or will. Bruna was a man of taste whose library

and cabinet of curiosities was considered by Ceán Bermúdez to be the one of the largest in Spain[13]. He resided in the Alcazar, and his own notable collection of artistic, archaeological and historical artefacts including documents relating to Murillo, was mixed in with that of the Academy. After his death his own collection, mistakenly incorporating some of the Academy's, was sold off or offered to the King. In this way the Academy lost its Velázquez, *Adoration of the Kings* (now in the Prado), and a painting measuring about one metre by 75 centimetres described merely as a *Virgin and Child*, which might speculatively be proposed as the Murillo fragment. At that time Madrid was teeming with diplomats, dealers and agents from all over Europe, France, the Netherlands, Denmark and of course Britain, all eager for the rich pickings which might result as invasion loomed over the Spanish peninsula early in 1808 and private art collections or war loot emerged on to the market. Some even made it down to the still lucrative but more inaccessible market of Seville. One such, Jean-Baptiste Le Brun, an artist-dealer better known then and now as the portrait painter Vigee Le Brun's husband, spent an enjoyable summer in 1807 being shown round the city's artistic highlights by a local knowledgeable dealer, Jean Frederic Quilliet, and attempting to buy what he could. He might well have acquired the Murillo fragment.

Seville was totally embroiled in Spain's five year war of independence from French and Napoleonic domination between 1808 and 1813, and was frequently captured, relieved and occupied by French and British troops and their allies. In 1810 the French army took the city, and its commander-in-chief, Marshal Nicolas Jean de Dieu Soult (1769-1851), made the Archbishop's Palace his headquarters, holding elegant soirees and balls for Seville society and his officers throughout their two-year stay. Soult was one of the youngest marshals in Napoleon's army and the leading French general in Spain. (illus. 12). His success in battle led to him receiving the dukedom of Dalmatia, whilst his activities in Spain enriched him in a totally different way, earning him the nickname of 'the plunder marshal general'. During the five years he was in Spain he collected booty for his private art collection as well as campaign honours. Many anecdotes were told of the number of 'gifts' presented

to the Marshal or 'offered' once threats to property or life had been made. Murillo was Soult's particular favourite. Fifteen of the artist's works, including some of the masterpieces which he had painted for the Caridad, were amongst the 109 Spanish school paintings sold from Soult's famous collection in May

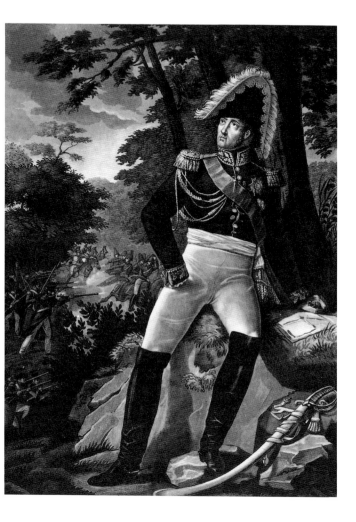

Illus. 12 Engraving by Charon after Aubrey, *Portrait of Marshal Soult.*

1852 after his death. When Soult took up residence in the Archbishop's Palace the remnant of Murillo's altarpiece showing the lower half of the Virgin's body being lifted by a golden throng of cherubs was probably still in situ in the now disused private chapel. Soult ordered the collection of Seville's art treasures from its churches, monasteries, convents, hospitals and other religious institutions, a task aided

by the use of Ceán Bermúdez's recently published *Dictionary of Spanish Artists*, one of the most reliable and erudite guides to a country's art then to be found in any European country. The collection of 999 paintings was intended for a Napoleonic art gallery to be sited either in Madrid or in Paris at the Louvre. However, several of the most important works, including the Murillo altarpiece and the accompanying series of paintings by Valdés Leal, ended up in Soult's own collection, eventually adorning the reception rooms and salons of his Paris house. From the time he acquired the Murillo remnant Soult continuously attempted to find the missing section, sending to England General Louis Francois Lejeune, a fellow military officer and artist, and other envoys to enquire after and secure it. In the meanwhile he had the missing section filled, allegedly with a copy painted by Lejeune (Cat. No. 7).

The Later History of the *Virgin and Child in Glory:*
(2) Acclaim and Declining Reputation

The period during which the *Virgin and Child in Glory* was divided, surreptitiously exported and reconstituted coincided with the zenith of Murillo's reputation amongst British connoisseurs, collectors, dealers and artists. The Spaniard's technically superb handling of paint with which he created scenes suffused with light, rich melting shadows and blurred profiles; his colour tones of mellow yellows, dusty browns and silvery greys enlivened with flashes of lilac, pink and pale blue were much appreciated by British painters of the period such as Reynolds, Gainsborough and later Wilkie. Murillo's colouring - always more muted than that of his contemporaries - was after all much closer to that of the eighteenth century. Reynolds's acquaintance with Spanish art did not derive from any close contact with the country itself other than that felt when he fell from his horse whilst on a youthful visit to the British-held island of Menorca in 1749. His knowledge sprang rather from familiarity with a number of the British aristocratic collections which already possessed paintings by Murillo. In turn Reynolds often acted as an artistic advisor to their owners. In 1785 he

commended to the Duke of Rutland that Murillo's *Self-Portrait* (Cat. No. 1) 'which I have seen is very finely painted …. it will be a very considerable acquisition to your Grace's collection'.[14]

The late eighteenth-century affection for a world of lost innocence and childhood play increased Murillo's appeal amongst collectors of taste and inspired the 'fancy pictures' of both Reynolds and Gainsborough. He was seen as an Old Master whose themes and colours harmonized with the eighteenth-century family portraits and landscapes which hung alongside his works in their collections. Murillo's reputation survived the change in taste wrought by the Romantic movement as his art appeared also to embody their ethos, a blending of the sublime with the mundane. Murillo's 'fancy pictures' of urchins at play had a consistent appeal to English collectors who, distanced from Seville's reality, might view them as recreations of a playful carefree existence. But equally his portrayal of virginal beauty, innocence and faith could be admired once its religious content was ignored. Disregarding such content was made easy since underlying both Murillo's secular and religious pictures was the same naturalistic intent and ideal of humanity. Often similar imagery and postures recur in his altarpieces as in his scenes of everyday life. Thus Gainsborough was able to drink in Murillo's influence by copying in 1780 a religious work supposedly by him, *The Christ Child as the Good Shepherd* (illus. 13) yet reflect it in a romanticized secular image of a *Shepherd Boy* (illus. 14). William Hazlitt encapsulated the idea when he wrote 'If a picture is admirable in its kind we do not give ourselves much trouble about the subject'.[15] Gainsborough was knowledgeable about Murillo's work and familiar with his style. On more than one occasion he copied his works, which could already be found in sizeable numbers in British collections and acquired for his personal collection one painting by the artist, *St. John the Baptist in the Wilderness*, (now in the National Gallery, London, where it is considered a studio piece). The themes he chose to copy or buy were a mixture of the religious and secular genre, such as Dyrham Park's *A Peasant Woman and a Boy*. The subject did not matter as much as the vaporous painted effects and subdued colouring which Gainsborough admired and transferred to his own

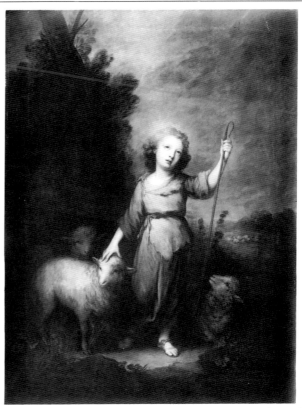

Illus. 13 Gainsborough's copy after a copy by Grimoux, of Murillo's *Christ Child as the Good Shepherd*

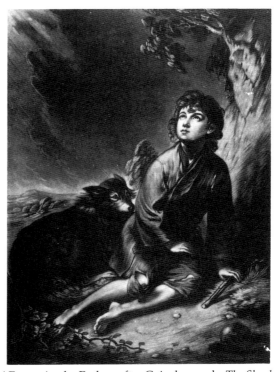

Illus. 14 Engraving by Earlom after Gainsborough, *The Shepherd Boy*

paintings. Reynolds, besides recommending the purchase of Murillo's work to his aristocratic patrons, subsumed his influence into his own work. Hazlitt, an early nineteenth-century commentator with many eighteenth-century attitudes to art, considered that the *Beggar Boys* (Cat. No. 9) was not only the triumph of the Dulwich Collection but almost of painting itself. For him Murillo's paintings did not merely represent common life as did the Dutch but actually were real life with a spirit all of their own distinct from the Italians and Dutch and unforgettable once seen.

For any collector of whatever standing wishing to build up a reputable holding of paintings at the beginning of the nineteenth century Murillo was therefore a name to seek out. One such person was Edward Gray of Haringay House who by 1824 had acquired the central section of the *Virgin and Child in Glory*. He was an elderly City merchant and former linen-draper who having retired used his sizeable earned wealth to start building himself a substantial villa in 1793. Haringay House in what was then the Middlesex village of Hornsey was surrounded by landscaped gardens, in which Gray succeeded in growing the first camellia in England, and was intended to house him and his gradually expanding collection. On his death in 1838 this included not only a large number of paintings but also books of prints, bronzes, marbles and Etruscan vases. He was typical of many a self-made, nouveau-riche, non-aristocratic, and in his case Quaker-inclined, collector who emerged on the art scene in the early nineteenth century. Like other contemporaries he did not profess to be a connoisseur, indeed he was described by William Wilkins, the future architect of the National Gallery, in a court case held before the King's Bench in 1832 as 'possessing no (artistic) judgement whatever: he did not know a copy from an original'.[16] However, conscious of his own want of knowledge, Gray relied instead on advice, initially from art dealers and later from knowledgeable acquaintances and artist-advisors, like William Wilkins, to purchase domestic-sized Dutch paintings such as the Wouwermans landscape now in the Wallace Collection (no. 218) and supposed examples by Italian and Flemish Old Masters. His lack of judgement earned him great experience of the more disreputable activities and characters of several dealers of the time and resulted

in two sensational court cases in 1817 and 1832. In the former Gray successfully sued a Bond Street dealer for fraud, receiving £10,000 in compensation. His experiences with another dealer, William Buchanan, were less troublesome. It was through him that Gray had acquired by 1824 a Rembrandt portrait of *Hendrickje Stoffels* and most probably the central section of the Murillo altarpiece which Buchanan could have obtained from the French dealer J. P. B. Lebrun, with whom he was in contact and from whom he purchased a Murillo study in oil for an *Assumption of the Virgin*.[17] The Murillo fragment would have been precisely the type of painting to attract Edward Gray. It was small and therefore probably relatively cheap and yet it was by a 'big name' artist whose work was highly regarded by British society. Although most of his collection consisted of Dutch landscapes, portraits and genre scenes, the style and sacred theme of the Murillo

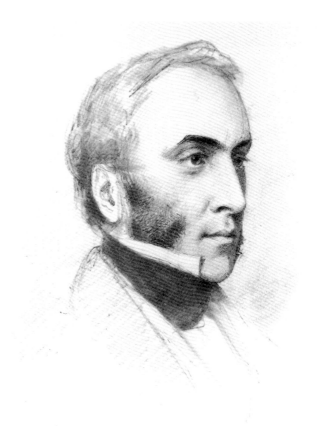

Illus. 15 Upton Eddis *Portrait of Samuel Jones Loyd*

would have complemented the Van Dyck *Infants Christ and St. John* which he also owned. On his death in September 1838 most of the paintings were acquired by James Morrison, an even wealthier City merchant, through a financial arrangement made with Buchanan. The Murillo *Virgin and Child* slipped this net however. It had already been sold by Buchanan to Samuel Jones Loyd, later Baron Overstone, another self-made man whose wealth, financial acumen and artistic expertise, however, was of a totally different order from Gray's (illus. 15).

Lord Overstone's *Times* obituary in November 1883 described him as Britain's leading authority on all matters connected with trade and finance. He was one of the shrewdest of his banking generation, 'a financial genius'.[18] The advice he gave on currency, banking and financial matters to his political friends in government and the establishment of a newly strengthened Bank of England led to his ennoblement in 1850. His fortune derived partly from that of his father, estimated in 1858 to have been over three million pounds, and from his own financial intelligence which he used as the director of his father's private bank Jones Loyd and Co. from 1844 until its absorbtion into what eventually became National Westminster Bank. The rather withdrawn and shy impression which he made on acquaintances and society in general can be gauged from the plausible suggestion that he was the model for Dickens's aloof banker Dombey in *Dombey and Son* (1848). Financial matters were not, however, his only interest. His art collection - acquired from the mid 1830s onwards, perhaps in friendly rivalry with a fellow banker Sir Thomas Baring - gained a distinguished reputation across Europe. It included masterpieces such as Claude's *Enchanted Castle* (National Gallery) and several paintings by Murillo. In 1850 he was made a National Gallery trustee. Taking his duties seriously, he advised the Keeper on possible acquisitions of paintings which he had seen abroad, and as the Gallery's spokesman in the House of Lords defended its purchases from attack by Lords and M.P.s. At a Select Committee hearing held in 1853 to enquire into the Gallery's affairs he stoutly justified its recent purchases of Spanish art against aggressive questioning, saying he could not 'for a moment listen to the idea that the Spanish School is a school from the

study of which nothing is gained'.[19] The M.P.s' criticisms of Spanish art's supposed unimportance may have hit home more forcefully than they might have imagined. Early in his collecting career Overstone had purchased several works by Murillo, including the Gray fragment, and within a few years of his appearance before the M.P.s he had begun negotiations with the Soult family for the purchase of the remains of the Murillo altarpiece which the Marshal had looted from the Archbishop's Palace in Seville some forty years previously. When Overstone acquired Edward Gray's bust-length *Virgin and Child* in 1838 he was probably totally unaware of its true origin. Once he had fortuitously discovered its source, he resolved to reunite the two, refusing offers from Soult who himself wished to purchase the Gray fragment.

In 1862, some years after he had bought the Soult painting, he used his position as a National Gallery trustee to obtain the services of the Gallery's restorer, Signor Pinti, in removing the inserted copy and skilfully reuniting the two pieces. Thanks to Overstone's determination, for the first time in almost eighty years the altarpiece was as Murillo had painted it, except that it no longer hung in an archbishop's private chapel but in the country home of a millionaire banker alongside his substantial collection, amongst panelled woodwork and red silk wall-coverings. Although the collection as a whole was not much seen by the general public, as it was divided between private residences in London and Berkshire, Overstone regularly lent to Old Master exhibitions including the major Art Treasures exhibition held in Manchester in 1857, for which he was the leading promoter. He would no doubt have approved when almost a century after his purchase of the Soult painting the National Art-Collections Fund decided to present the painting to the Walker Art Gallery in celebration of its refurbishment and recent reopening (1951) after the Second World War. For as his *Times* obituary pointed out, his 'excellent good taste … was ever directed by a high feeling of public spirit and an earnest and serious concern that grand pictures should be brought to exercise their elevating influence upon the people'.

The first half of the nineteenth century was the absolute height of Murillo's prestige in Britain and abroad. The 1830s saw a compulsive curiosity about

anything Spanish on both sides of the Channel and at the most prominent levels of society. The French king, Louis Philippe (1830-48), opened his collection of Spanish paintings to the public as the Galerie Espagnole in 1838, whilst two years earlier the youthful Princess Victoria had confided to her journal her admiration for the paintings of Murillo, which she pronounced 'beautiful' and 'exquisite'.[20] This interest in all things Spanish was partly stimulated by the influx into Britain of political refugees from Spain, but it had also been sparked off by a growing artistic curiosity about the country itself in the wake of the Spanish Peninsular Wars. David Wilkie considered his tour of Spain in 1828, the first by any major British artist, to have been the 'best employed time of my professional life'. It helped him recover from a nervous breakdown and revived his interest in painting. He regarded the country as 'the wild unpoached (artistic) game-reserve of Europe'. He came away impressed if not overawed by Murillo's artistic status and high reputation in Spain, particularly in Seville where he was almost revered. He commented favourably in his Journal and letters that 'for female and infantine beauty, scarce any has surpassed him' and thought he saw real-life Murillesque madonnas and children on every street corner.[21] The tributes which the Scottish artist paid to the Spaniard in paint consistently emphasize these themes (Cat. No. 12). Wilkie's own sympathy with the activities and taste of the common people, as demonstrated in his own paintings of Scottish life, must have attracted him to Murillo. An empathy is suggested by his continual comments and asides in letters and Journal about how good art could be popular, indeed must be so to be influential, and vice versa. His involvement with Murillo was such that a print produced to illustrate his journey was entitled *David Wilkie in search of Murillo* (illus. 16). In the decades after Wilkie's visit other artists flocked to Spain and the book market was deluged with guide books to the country, its customs, antiquities and art treasures, culminating in Richard Ford's *Handbook for Travellers in Spain* (1845) and Sir William Stirling-Maxwell's *Annals of the Artists of Spain* (1848). Another Scottish painter, John 'Spanish' Phillip, literally made his name by painting scenes of Spanish life inspired by his tours in 1851, 1856 and 1860 and by his friendship with David Wilkie. Beneath his gypsy

mothers and their urchin children there often lay traces of a Murillo madonna. Phillip became one of Queen Victoria's favourite painters and the hint of the Murillesque in his art may have added to his appeal for the Queen.

Illus.16 Engraving by Willhope after Wilkie *David Wilkie in search of Murillo*

At the Soult auction of 1852 another of his Murillo Virgins, the *Immaculate Conception of Los Venerables*, sold for the highest price ever paid for a painting at that date. Murillo was the Van Gogh of the period, his paintings fetching sky-high prices. The popularity of his work now extended from connoisseurs and the nouveaux riches who coveted his paintings for their collections to the man and woman in the street who were used to seeing religious and edifying texts and family Bibles illustrated with prints and engravings which copied his devotional images. At the Great Exhibition of 1851 one firm, Jeffrey, Allen & Co., even offered for sale, perhaps as a novelty piece, Murillo wallpaper based on urchin paintings at Dulwich and Munich (illus. 17). The most popular images were those of children. Secular or religious, they were enjoyed as pleasing portraits of everyday activities and emotions. When the cartoonist Dicky Doyle wanted to show the popular pastime of Gallery-going, he depicted his eponymous hero peering at the National Gallery's recently acquired Murillo, *The*

Infant St. John the Baptist, which soon became the Gallery's most frequently copied painting.

This popularity, however, sowed the seeds of Murillo's fall from grace amongst artists, critics and connoisseurs, as David Wilkie acknowledged when he

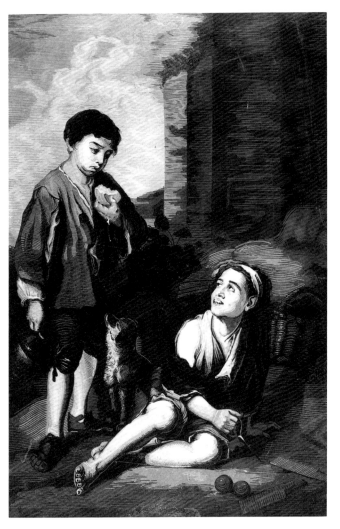

Illus.17 Wallpaper panel produced by Jeffrey, Allen and Co. after Dulwich Art Gallery's *Two Peasant Boys* by Murillo.

wrote, 'Murillo is a universal favourite and perhaps suffers in the estimation of some only because all can admire him', referring later to 'the prejudice amongst painters who suppose the great qualities of art can be appreciated only by the few'.[22] Wilkie himself had originally gone to Spain in search not of Murillo but of his less well known but highly regarded compatriot Velázquez, whose rising star eventually ousted him. Murillo's style did not lend itself to reproduction in

black and white hard-edged engravings, whose often appalling quality transformed his children into gruesomely saccharine figures. By the 1840s Seville was full of hack artists earning a living by producing mediocre copies or fake Murillos for the tourist market. The combination of a new Spanish master to admire, bad reproductions and poor copies did much to undermine Murillo's artistic prestige. They clouded and ultimately distorted the perception of Murillo as an artist. He was too popular for his own good and the fall had to come. When it did it was dramatic. By the end of the nineteenth century the Spanish artist's own naturalistic vision and vigorous painting was no longer acknowledged in artistic circles, where a more sombre form of naturalism was in vogue. The Dutch realist painter Jozef Israels (1824-1911) complained of the lack of a master's touch in Murillo's work, writing in 1898, 'O sacred Murillo you are too sweet for my taste … With you everything is smooth and nice in colour and form …. Rubens, with a single turn, a single smudge of his brush, betrays his character and the idiosyncrasy of his talent. With you on the other hand, this is replaced by an uniformity of execution that gives one nothing to take hold of: always the same colour-scheme, the same treatment, which makes everything soft and smooth. Dare I call you the painter of pious insipidity?'.[23]

Even in his native Spain the century's end saw a movement away from appreciating Murillo as a naturalist to that of viewing him as a religious idealist and finally seeing in him only a 'painter to the court of the celestial Queen'.

The dissatisfaction with Murillo's slick painterly technique and the perception of his artistic role as merely that of a propagandist defender of the Catholic faith first emerged in Britain in the middle of the century. Ruskin, referring to his vaporous painted effects and lost silhouettes, railed against the artist's 'vicious slurring and softness' and idiosyncratically equated his slurred technique with a slurred morality.[24] A crucial element in his declining reputation may have been the anti-Catholicism which permeated the mid-century intellectual circles of writers such as Ruskin and Carlyle. Murillo was viewed as the most successful instrument of the Catholic Church's most notorious member, the

Spanish Church. Ruskin's early strictures had not been levelled at the insipidness of the artist's figures but at their coarse, forthright naturalism, the vulgarity of his savage-featured children. When brightly clothed Pre-Raphaelite red-headed beauties were all the rage, Murillo's subdued colours and dark almond-eyed Madonnas no longer had the physical appeal which they had enjoyed earlier in the century. At the dawn of the twentieth century Murillo could no longer satisfy either those like Israels who called for a more sombre, less feeble form of naturalism in tune with that of Velázquez nor those who considered his work too humanistic and lacking the spirituality which they had discovered in Zurbarán and El Greco.

After this fall from grace the controversy which surrounded the acquisition by the Walker Art Gallery of the Murillo *Virgin and Child in Glory* may not be considered too surprising. In 1953 the National Art-Collections Fund, having acquired the painting from Lord Overstone's descendants, decided to present it to the Walker in celebration of the Gallery's recent reopening and decoration after World War II. Although its status as a major and beautiful work of art by one of Europe's leading artists was acknowledged, a former director of the Gallery threatened to withdraw his subscription from the N.A-C.F. over its funding of the acquisition. It was only the painting's comparative lack of 'excessive sentimentality' that helped persuade councillors and other decision-makers that it was a suitable addition to the Walker's collection. Now that our eyes are no longer clouded by either the hagiography of the early nineteenth century or the disparagement of the first half of the twentieth, perhaps we can look more clearly at Murillo's pictures as masterpieces of naturalistic observation of maternal, paternal and infant behaviour. Though his work is far removed from the dynamism of Rubens or the theatricality of Italian painters, the restrained religious fervour of his biblical scenes makes him undoubtedly one of the most affecting painters of the baroque era as well as probably the best interpreter of Catholic sensibility of his or any time. Above all Murillo is able to appeal to our human sympathies through his skill. For as the nineteenth-century art commentator Anna Jameson wrote, his talent lay in an ability to wrap 'the most awful feelings of our faith, as well as the deepest feelings of our nature, in forms the most familiar'.[25]

The Walker Art Gallery's *Virgin and Child in Glory* is a supreme example of that talent and of Murillo's mastery of pictorial art.

FOOTNOTES

1. J.H. Elliott, 'Art and Decline in Seventeenth-Century Spain', Royal Academy Exhibition Catalogue, 1982, p.46

2. Historical Manuscripts Commission, Series 63, *Diary of the first Earl Egmont (Viscount Percival)*, 1923, pt.1, p.344

3. Archivo de Protocolos, Seville, Oficio 24, fol. 537

4. Juan de Loaysa, *Pésame ….*, 1684, p.58; Morgado, *Prelados Sevillanos*, 1899-1904, vol.II, p568-9

5. Archivo de Protocolos, Seville, Oficio 24, fol. 538

6. Loaysa, op. cit., p.7

7. This is the opinion of Duncan Kinkead given in a personal communication, 16 October 1988.

8. Ceán Bermúdez, *Diccionario Histórico*, 1800, vol.IV p.114

9. Palomino, *Lives*, 1724, ed.1987, p.303

10. Ortiz de Zuñiga, *Anales*, 1671, p.808

11. Ponz, *Viage de España*, 1780, vol.9, p.189

12. Matute y Gaviria, 'Adiciones y Correciones', *Archivo Hispalense*, 1888, vol.IV, p.199

13. Romero y Murube, *Francisco de Bruna y Ahumada*, 1965, p.58

14. Historical Manuscripts Commission, Series 24, *Fourteenth Report I, Rutland*, iii, p.268

15. William Hazlitt, *Criticisms on Art*, 2nd ed., 1856, p.29

16. Gray v Nieuwenhuys, *The Times*, 26 June 1832

17. Buchanan, *Memoirs of Painting*, 1824, Vol.2, Index for Mr. Gray p.265

18. *The Times*, 19 November 1883

19. *Parliamentary Select Committee Report on the National Gallery*, 1853, vol.35, para.5406-7

20. Princess Victoria's Journal, 3 August 1836. Published by gracious permission of Her Majesty the Queen.

21. Cunningham, *Life of Sir David Wilkie*, 1843, vol.II, pp. 486- 7, 521, 524; F. Irwin, 'The Scots discover Spain', *Apollo*, 1974, vol.99, p.353

22. Cunningham, *Life*, pp.473, 487

23. N. Glendinning, 'Review of Murillo Exhibition', *Kunstchronik*, 1983, p.126

24. E.T. Cook and A. Wedderburn, *Works of John Ruskin*, vol.3, p.323n

25. A. Jameson, *Companion to the Celebrated Private Galleries of Art in London*, 1844, p.172-3

· C A T A L O G U E ·

Measurements are given in centimetres, height before width.
References have been kept to a minimum

1.
BARTOLOMÉ ESTEBAN MURILLO (1617-82)
Self-portrait
122 x 107cm
(Trustees of the National Gallery, London)

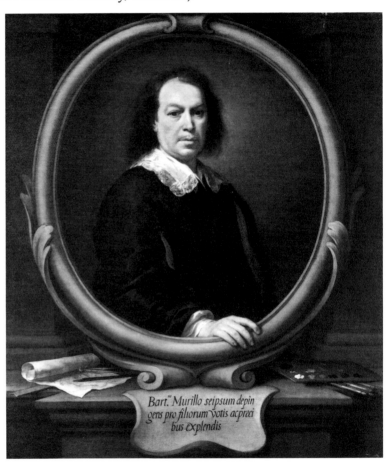

As the Latin inscription on the tablet hanging from the ledge explains, this self-portrait was painted by Murillo 'to fulfil the wishes and prayers of his children'. The portrait may have been painted by 1672, when Murillo's four surviving children from a family of nine, José, Francisca, Gabriel and Gaspar, were aged twenty-five, seventeen, fifteen and eleven respectively. The painting is far more than just a dignified self-portrait on the finest of canvases of a well-off artist painted at the express wish of his children, although this itself makes it unusual. The inscription makes no grandiose claims for Murillo or his art, as was common in the engraved portraits which this picture resembles. Instead Murillo lets the painting make his claims for him. In it he declares his allegiance to painting and drawing. The picture is also a commentary on the art of painting, its simulation and dissimulation, and on Murillo's art in particular. He has painted himself within an oval frame as if his self-portrait is a painting of a painting, but the artist's hand which rests over the 'frame' destroys this illusion, introducing instead a sense of life-like three-dimensionality to the figure and emphasizing further the ambiguity of space in the picture and in painting generally. Murillo's hand also subtly points the viewer to his palette, with its orderly row of the pigments used by Murillo to paint the portrait. Other tools of the painter's trade and Murillo's in particular are shown on the other side of the ledge: a rule, brass dividers and the red chalk holder with which he often drew figure studies similar to the partially scrolled drawing underneath. As a final reference to Murillo's own art the drawing appears to show a life study of a young boy in a posture similar to that of some of his favourite themes, infant saints and urchin boys at play. The *Self-portrait* was the earliest identifiable work by the artist in British hands. Imported into England by 1729 and later owned by Frederick, Prince of Wales, its reputation quickly spread. By 1785 Sir Joshua Reynolds was recommending it as a suitable purchase to the Duke of Rutland.

Literature: N. Maclaren and A. Braham, *National Gallery Catalogue:the Spanish School*, revised ed. 1988; M. Helston, *National Gallery Schools of Painting: Spanish and Later Italian*, 1983

2.
BARTOLOMÉ ESTEBAN MURILLO (1617-82)
The Holy Family
96.5 x 68.5cm
(Duke of Devonshire and the Chatsworth Settlement Trustees)

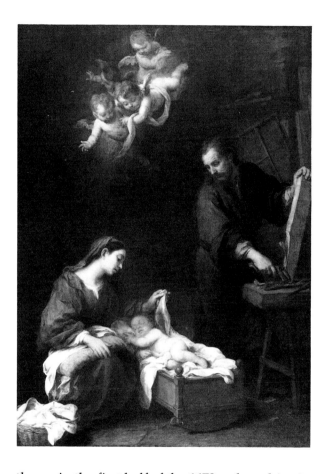

Murillo, like his Dutch contemporary Rembrandt, has always been much admired for his ability to blend religious imagery with convincing evocations of scenes from daily life. In seventeenth-century Spain this talent was particularly appreciated by the Counter-Reformation Church, eager to maintain and encourage spiritual devotion amongst the people through images with which they could identify. The Chatsworth *Holy Family* focuses on an intimate scene of parental tenderness as both Mary and Joseph halt from their respective labours to gaze at their sleeping child. The family is presented as an ordinary working couple of Seville engaged in mundane human activities in the humble setting of a carpenter's workshop. None of the figures is shown with a halo or surrounded by celestial golden aureoles; instead Murillo introduces the sacred in the form of the cupid group gently hovering above the infant Christ, casting a warm, candlelit-like flicker over the scene. The atmospheric intimacy and enchantment created by the softly contrasted light and shadow is reminiscent of several paintings by Rembrandt, an artist known in Seville. A typically shadowed Rembrandt was one of the paintings exhibited to celebrate the redecoration of the church of Santa Maria la Blanca in 1665 in the street opposite the mansion owned by Murillo's friend and patron the Marques of Villamanrique. As in almost all Murillo's Holy Family scenes, Joseph is shown as a vigorous working man sharing in the childhood of Christ. Spanish religious orders such as the Jesuits and the reformed Carmelites, established by St. Theresa of Avila, gave particular prominence to this newly virile St. Joseph, promoting his cult from the late sixteenth century into the seventeenth. Murillo consistently used such a model of paternal love in his paintings, keeping strictly to the Spanish theological view that Joseph should be shown in his mid thirties. The scene's calm tranquility, emphasized by the sleeping child, an important Murillesque

theme in the first half of the 1670s when this picture was painted (Cat. No. 3), was specific to Murillo. Valdés Leal, a Sevillian contemporary in tune with a more intense mysticism, painted equivalent subjects in which the agitated celestial figures almost crowd out the Holy Family and their domestic setting.

Literature:
Royal Academy, Murillo Exhibition Catalogue, 1982-3; Angulo, *Murillo*, 1981

3.
BARTOLOMÉ ESTEBAN MURILLO (1617-82)
The Christ Child Asleep on the Cross
141 x 108cm
(City Art Galleries, Sheffield)

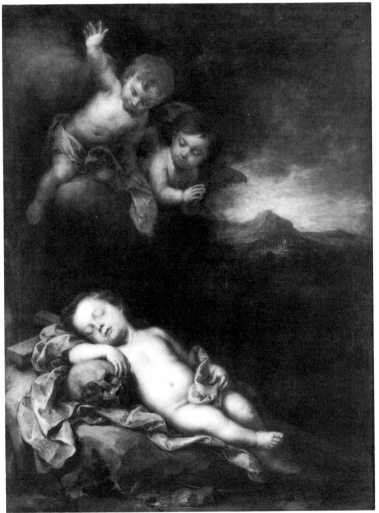

Some of Murillo's most sensitive and attractive religious works were the result of his response to the opportunities offerred by painting children. They were also the most popular, as is apparent by the variety of scenes from the childhood of Christ, St. John the Baptist and other saints produced by the artist and his workshop. Here the innocent, graceful form of the sleeping child and his protective, dream-like guardian angels totally subsume the painting's sombre themes, the premonition of Christ's death represented by the cross upon which he lies and the knowledge of his eventual triumph over death signified by the skull over which his arm is lightly draped. The subject of the *Christ Child asleep on the cross* had been popularized earlier in the century by the Italian artist Guido Reni. Prints and copies of Reni's original composition (like that in the Walker Art Gallery) (illus. 3) may have inspired Murillo's own portrayal, though his Christ is more naturalistically posed and less obviously derived from classical sculpture than Reni's. Devotion to the Infant Christ was promoted by the Church to encourage the believer to submit to God's will with the ingenuousness of a child. Murillo's masterly depiction of innocent and tender faith was essential to its successful portrayal. The expression of childhood innocence suffused with the painting's colouring, the pinks and mauves of the drapery, the earthy yellows and silvery-greys of the visionary landscape which lies behind, all prefigure eighteenth-century Rococo taste and sentiment. By the second half of that century the painting was already in an English collection, as was the Buccleuch *Infant St.John* (Cat. No. 4), to which it could almost hang as a pendant, so close is the similarity of size and dramatic lighting.

Literature:
Royal Academy, Murillo Exhibition Catalogue, 1982-3;
Angulo, *Murillo*, 1981

4.
BARTOLOMÉ ESTEBAN MURILLO (1617-82)
The Infant St.John the Baptist
141.5 x 107cm
(Collection of The Duke of Buccleuch)

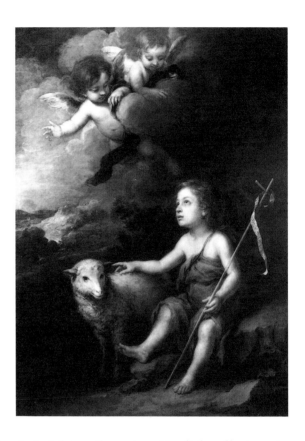

The Infant St. John playing with a lamb was a common Murillesque theme which he often paired with the Christ Child as the Good Shepherd. Both subjects reflected a particularly Spanish form of piety which favoured the depiction of both Christ and St. John the Baptist in their infancy, emphasizing their innocence, spirituality and a recognizably playful humanity. This sensibility permeated all levels of society. Indeed the painting may have been the one which Murillo proferred to the Spanish king in 1670 in compensation when he refused a post at court. The subject derives from a passage concerning St. John's childhood in St. Luke's Gospel (Luke 1:80): 'And the Child grew and waxed strong in spirit and was in the deserts till the day of his showing unto Israel', which explains the dramatically lit and beautifully austere background landscape, for which Murillo was much admired in his lifetime. The vernacular legends that surrounded St. John's youth were full of detail which added to their human interest. Compared to other Murillo versions of the scene this vision is more emotionally restrained, less playful or ecstatic. Instead a pensive saint throws a gently earnest gaze towards the celestial cherubs, who clamber over the clouds and peer down in their efforts to watch over him. The viewer's attention, however, is insistently attracted by the intense, almost anthropomorphic stare of the lamb, the only figure to look out at us. It appears to view us with the same look of concern which the Christ Child bestows on the worshipper of the Walker's Murillo altarpiece. This is as it should be, for the lamb represents Christ. John the Baptist had proclaimed when he recognized Jesus, 'Behold the lamb of God' (John 1:36). The lamb's stare is thus meant to act as a visual clue to the Baptist's future recognition of the Saviour. Despite the theological message, the recognizable humanity of Murillo's child saint and cherubs creates a parallel with many of his street life scenes. It was this parallel which may have attracted eighteenth century English collectors, to whom such pictures were charming paintings of children rather than devotional images. This picture was one of the earliest by the artist to be imported into England. By 1757 it had been bought by Lady Cardigan from Mr. Bagnall, the same collector who had owned the *Self-portrait* (Cat. No. 1) in 1729.

Literature:
Royal Academy, Murillo Exhibition Catalogue, 1982-3; Angulo, *Murillo*, 1981

5.
BARTOLOMÉ ESTEBAN MURILLO (1617-82)
Virgin and Child in Glory
236 x 169cm
(The Board of Trustees of the National Museums and Galleries on Merseyside)

Despite its grandeur of conception and large scale, the altarpiece is a very intimate picture, an image of humanity and maternal affection, as befits its original context. It was always intended for the private and personal devotion of the devout Archbishop Spínola of Seville (1670-84). The intimacy of the image is sustained by the directness of the Christ Child's glance which engages with the worshipper contemplating the altarpiece from below. Nothing is allowed to distract from this vision of a mother who clasps her child tenderly to her as they both stare with pensive concern at the viewer. The image is intended as a vision appearing only to the spectator. Even the gambolling cherubs do not detract from the vision for their expressions reflect those of the central figures. The painting's unity of expression is unlike the altarpiece with which it is often compared, the *Virgin and Child in Glory with Saints* (the Sistine Madonna) painted by Raphael in the previous century (illus. 18). Raphael's cheeky cherubs and relaxed, almost lounging, Christ Child introduce a secular note whilst the wildly billowing drapery and the interceding Pope and saint distract from the central image. The stillness of Murillo's icon-like figure contrasts with his typical heavenly Virgin impelled diagonally upwards in an apotheosis of baroque movement. Her stance is instead reminiscent of the Byzantine derived medieval paintings and painted wood sculpture characteristic of Spanish altarpieces which may well have affected the artist's compositional choice, for they were Archbishop Spínola's favoured source of spiritual comfort. The patron's artistic taste may also have influenced the choice of deep saturated reds and blues worn by the Virgin. The colours were traditionally associated with the Virgin but the rich tones used here reflect the colour schemes favoured by Rubens and Van Dyck, artists whom Spínola knew well and appreciated from his own and his family's picture collection. Murillo's more characteristic colour scheme for his late pictures can be seen in the light pinks and pastel blues of the Dulwich Collection's *Madonna of the Rosary* (Cat. No. 8). The pale skin tonalities of the latter also contrast with the naturalistically depicted swarthiness of the Walker's altarpiece. The dark-skinned features of his religious figures often attracted the attention of nineteenth-century British commentators who liked to refer to (or complain about) Murillo's peasant-featured 'gypsy Madonnas'. They could not conceive that such a realistically Andalucian complexion could represent an ideal. They assumed, without evidence, that the Virgin was modelled on a real person close to the artist, his wife or his daughter Francisca. The dark skin shared by Virgin, Child and cherubs does, however, introduce into the mystical vision a note of naturalism reiterated by the life-like movements of the cherubs. It was of course his ability to combine elements from the mundane world with the visionary - infinity with humanity and innocence with experience - that ensured Murillo's success as a religious artist for centuries to come.

Illus.18
Raphael
The Sistine Madonna

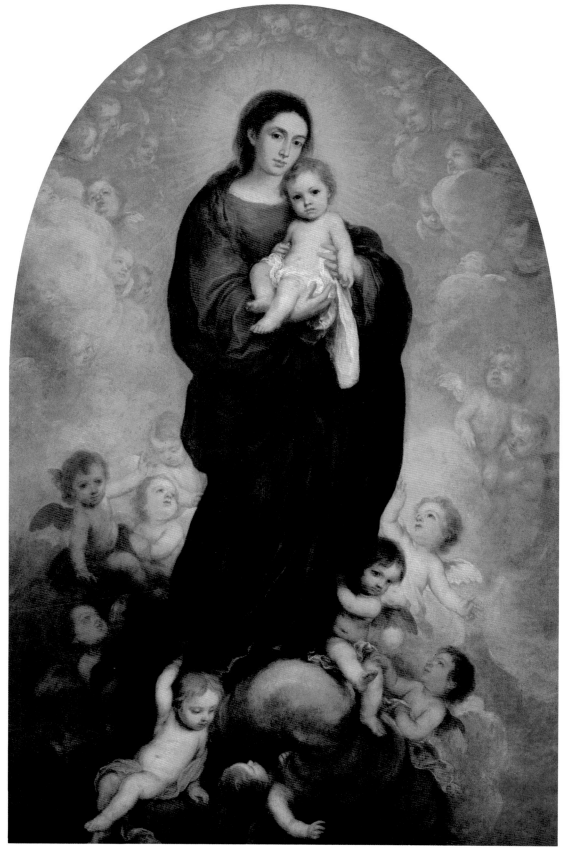

6.
BARTOLOMÉ ESTEBAN MURILLO (1617-82)
Oil Study for Virgin and Child in Glory
36.2 x 25.5cm
(Loyd collection)

This study may be the oil sketch painted by Murillo as a modello to show his patron Archbishop Spínola before commencing on the altarpiece. Thereafter it was probably kept in the Palace's collection, as it was later purchased by the English collector, Edward Gray, who also acquired the fragment severed from the altarpiece. From the variety of sketches, compositional studies and beautiful finished drawings known to have been produced by Murillo, it would appear that he prepared for his paintings very carefully. Like several of his oil studies the execution of this one appears rapid, particularly around the hands and faces, with several areas of the composition not fully developed. The arc of golden cherubs' heads circling above the Virgin's head in the finished altarpiece do not appear in the sketch, neither does the uppermost cherub clinging to her cloak on the left hand side. The looseness and lack of definition aids the greater display of dynamism found in the sketch compared to the finished painting. The overall effect, however, of soft, rounded forms bathed in light and atmosphere reflects the end result which in its turn retains the sketch's masterly intimacy.

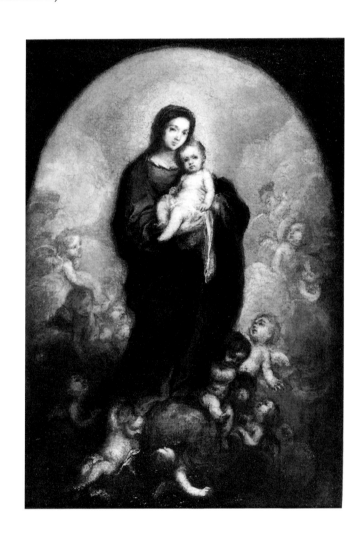

Literature:
L. Parris, *The Loyd Collection of Paintings and Drawings*, London, 1967

7.
Copy of the Virgin and Child
attributed to Louis Francois Lejeune (1775-1848)
89 x 66cm
(The Board of Trustees of the National Museums and Galleries on Merseyside)

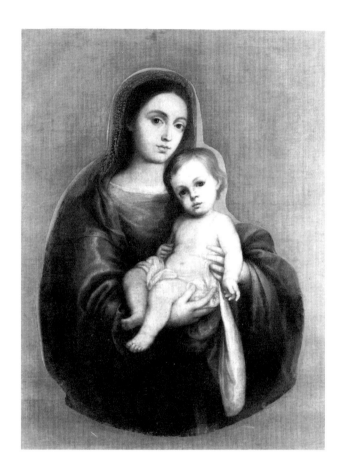

This copy of the central figures of the Virgin and Christ Child from Murillo's altarpiece is traditionally ascribed to General Lejeune and is supposed to have been commissioned by Marshal Soult for insertion into the altarpiece as a substitute for the missing portion. Lejeune not only fought in almost every major battle of the Napoleonic campaign in Spain but he also recorded many of them as an artist. As his journal of the Peninsular War shows he appreciated Spanish painting and often wrote disapprovingly of the looting of the country's art treasures by soldiers and officers. On one occasion he described a military encampment of the Napoleonic forces in which canvases and panels robbed from church altars had been used for makeshift shelters and bivouacs, turning the camp into a veritable outdoor art gallery, much to his own enjoyment. Although Lejeune was reputedly commissioned by Soult to paint this copy, the entry in the catalogue of Soult's collection refers to it being painted by 'a strange hand' *(une main étrangère)*. This suggests that he was unaware of the author of the copy and that it might be the canvas substituted whilst in the care of Pedro del Pozo, the Spanish artist and director of the Seville Academy of Fine Art between 1772 and 1785.

Literature: C. B. Curtis, *Velázquez and Murillo*, 1883

8.
BARTOLOMÉ ESTEBAN MURILLO (1617-82)
The Madonna of the Rosary
200 x 128cm
(The Governors of Dulwich Picture Gallery)

This altarpiece, probably painted some six or seven years after the Walker's *Virgin and Child in Glory*, shares its quiet intimacy. The same bitter-sweet contemplative gaze meets the worshipper's. These eyes which appear both to look fixedly at the viewer and yet also survey something far off particularly enthralled the Victorian poet, Alfred Tennyson, who referred to the ecstasy of a visionary created by the artist in his Dulwich Madonna, as the eyes 'seem to look at something beyond - beyond the Actual in to Abstraction'.[1] In both altarpieces the figures in the celestial visions exist in their own right commanding our attention and the devotion which was their spiritual function. The rosary with which the Christ Child plays suggests that the altarpiece was painted for a church of the Dominican Order, since the use of a rosary to count the sequence of prayers to the Virgin Mary was first instituted by St. Dominic. Often the Virgin or Child or both are shown holding out the rosary to Dominic and other members of the order. Here instead the Virgin and her child are shown on their own. The playful way in which Christ toys with the rosary is a characteristic Murillo touch which adds an appealingly human and familiar gesture to a grand religious painting. By omitting the usual lower order of saints the scene is presented as a purely devotional image in the same way as the Walker's altarpiece, rather than a historical event. The Dulwich altarpiece is one of only two paintings which bear any compositional resemblance to the Spínola commission and the only one to be painted in the same decade. There are, however, distinct differences between the two. Murillo's use of a lighter colour scheme more typical of his heavenly virgins introduces a lighthearted, carefree atmosphere, which appealed later in the eighteenth century to collectors, compared to the solemnity of the *Virgin and Child in Glory*. The seated pose provides a gentler outline whilst the fair complexions create what would

have seemed to Murillo's Spanish contemporaries as well as later British commentators a more idealized maternal couple. Finally, the rosary beads distinguish it from the *Virgin and Child in Glory*. Their inclusion serves to emphasize the unusual iconography - or rather lack of it - employed by Murillo in his commission for Spínola.

Literature:
Peter Murray, *Dulwich Picture Gallery*, 1980;
Peter Cherry, *Dulwich Picture Gallery Information Sheet 4: Spanish Painting*
Giles Waterfield, *Rich Summer of Art*, 1988

References:
Hallam, Lord Tennyson, *Tennyson and his Friends*, 1911, p.143

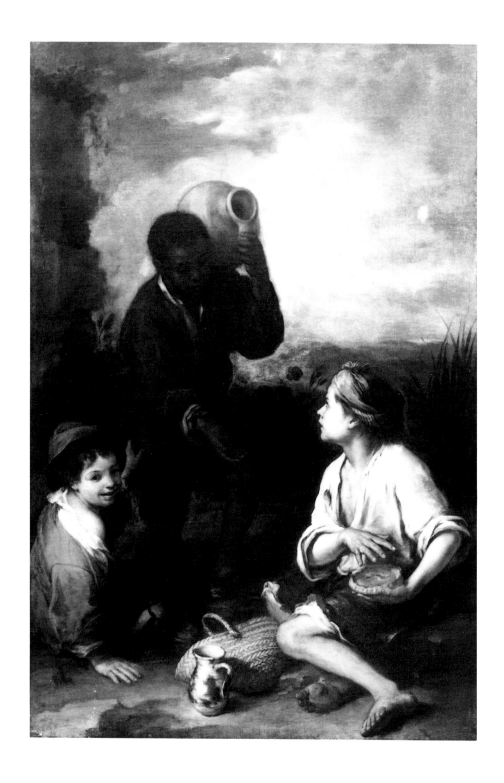

9.
BARTOLOMÉ ESTEBAN MURILLO 1617-82
Two Peasant Boys and a Negro Boy
168.3 x 109.8cm
(The Governors of Dulwich Picture Gallery)

Street urchin scenes were Murillo's most celebrated subject matter abroad during his own lifetime and over the two subsequent centuries. Though Murillo did not invent the genre, which has close Spanish literary precedents in the thieving low-life of the early seventeenth-century picaresque novel, he did much to make it visually his own. He introduced a spontaneity and a perceptive observation of the petty squabbles and teasing that erupt in the daily lives of children. The scene's visual understatement and ambiguity as the negro requests or perhaps demands a piece of the pie, serves to reinforce the viewer's feeling that it recreates an encounter perhaps witnessed by the artist on some wasteland in Seville. Murillo lived close by the main negro quarter of the city where young boys earned their keep as water sellers or could be hired to run errands, like the the boy in the picture. The model for the boy may have been Juan, the artist's own domestic slave whom he later freed, who was about eleven or twelve years old in 1670. The same acute observation of childish gestures and behaviour underlies Murillo's religious scenes. Sometimes the same postures recur: the cherub who looks out at us from the Walker's *Virgin and Child in Glory* is paralleled by the left-hand Dulwich urchin. The poor urchins, street-hawkers and negro errand boys who swarmed the streets of Seville are depicted sympathetically, without overt moralizing as to their own behaviour or what the conduct of others should be toward them. Despite the urchin's grime-encrusted foot thrust sole outwards towards the viewer, the painting can by no means be construed as a realistic portrayal of vagrant life in Seville when thousands would mill around the gates of the Archbishop's Palace to receive the daily dole of loaves. Nevertheless Murillo's street urchins may have hit too close to home for a Seville audience's comfort, which could account for their apparent lack of popularity amongst local Spanish collectors. By the end of the seventeenth century all his known beggar scenes were in collections outside Spain. One might conjecture that their appeal was strongest the further away the collectors were from Seville's wretched poverty. The link to his market further afield in northern Europe was probably provided by the artist's patrons amongst the large Flemish and Dutch merchant community in the city. The urchin paintings' non-specific settings, perhaps an idealized version of the semi-deserted allotments of the city's northern suburbs, encouraged viewers to regard them as depictions of universal childish pleasures. To some their seeming nostalgia for childhood assured them of popularity through the centuries. To others it was their naturalness of subject and evident reality that attracted. In 1824 the British commentator on art, William Hazlitt, was so delighted with their vitality, their high-spirited life-like qualities that he considered the Dulwich urchin paintings to be the 'triumph of the collection and almost of painting'.[1] However, the Victorian public's unquenchable craving for scenes of childhood and the twentieth-century reaction against such 'sentimentality' has meant that since then the originality of Murillo's scenes has often lain unappreciated.

Literature:
Peter Murray, *Dulwich Catalogue*, 1980;
Peter Cherry, *Information Sheet No.4: Spanish Painting*

References: William Hazlitt, *Sketches of the principal picture galleries in England*, 1824, p. 44

10.
Sir JOSHUA REYNOLDS (1723-92)
Master Wynn as St. John
69 x 90cm
(Williams-Wynn Trustees)

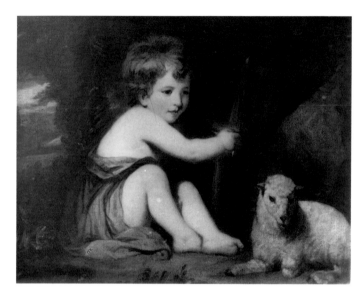

The young master Watkin Williams-Wynn's portrait was painted for one of Joshua Reynolds's most constant patrons. Between the late 1760s and the mid 1770s he worked on six separate commissions, including many family portraits, for the great Welsh landowner Sir Watkin Williams Wynn. Reynolds's status as the founding President of the newly established Royal Academy and his mastery of the child portrait would have made him an obvious choice. To Reynolds this painting was more than just a charming child portrait, as it also displayed his belief that the low status of the traditional British art of portrait painting could be raised only by treating it in the grand manner, grafting on to it the European old master tradition of 'history' painting. It was natural for Reynolds that in portraying a fresh-faced boy in a landscape setting, catching spring water in a dish, he should turn to the inspiration of Murillo for help in composing the picture. The relationship between the two artists was recognized as soon as the picture was painted. An engraved reproduction of it published in 1776 referred to the painting as *Master Wynn in the Character of St. John the Baptist* despite the child's lack of a symbolic cross. The title as much as the image and its mellow tones link Reynolds's secular picture with Murillo's religious paintings such as his *Infant St. John* (Cat. No. 4). The appreciative dependence of Reynolds on Murillo in the portrayal of children's innocent vulnerability was also identified by the reviewer of the Manchester Art Treasures Exhibition in 1857 who wrote of the Reynolds that it was 'very like a Spanish painting; when Reynolds painted it he must have been thinking of Murillo'.[1] There is a great deal of evidence that he was indeed 'thinking of Murillo' in the early 1770s. During this period he developed the 'fancy picture', paintings of children which illustrated their childish impishness, innocence and gravity. Several of these pictures, like the *Young Shepherd Boy* (1772) and *The Calling of Samuel* (1776), show Reynolds adapting favourite Murillesque postures and themes of infant saints and the Christ Child as the Good Shepherd. Examples of both themes could be found in aristocratic collections known to Reynolds. The Duke of Rutland, for whom Reynolds acted as an artistic advisor, owned a Murillo *Holy Family and Infant St. John*. The original devotional character of Murillo's images did not matter to Reynolds and his contemporaries. What they admired in Murillo and sought to emulate was his impressive painterly skills, his warm, mellow colouring and the subtle but sharp observation of gesture which combined to create images so close to the narrow tonal range and wistful charm of Reynolds's and Gainsborough's own child portraits and fancy pictures.

Literature:
Ellis Waterhouse, *Reynolds*, 1941;
Royal Academy, Reynolds Exhibition Catalogue, 1986

References: *Art Journal*, 1857, p. 280

11.
THOMAS GAINSBOROUGH (1727-88)
Cottage Girl with Pigs
125.8 x 148.6cm
(From the Castle Howard Collection)

First exhibited at the Royal Academy in 1782, this is one of the first of Gainsborough's 'fancy pictures' in which rustic figures were portrayed, often full-length, in a romantic landscape setting, with which he experimented in the last years of his life. Like Murillo, Gainsborough often used as models beggars and children he met in the neighbourhood of his home. The cottage girl's androgynous features may have

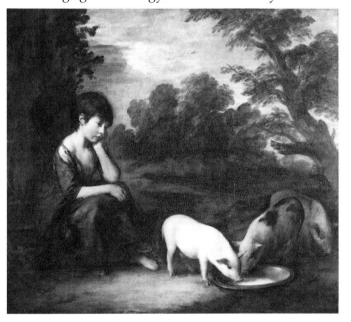

been those of a young girl he met on Richmond Hill, whom he painted again three years later. Various of these pictures seem inspired by the paintings of Murillo, whose work he admired. In 1780 he made a copy of a copy (which was then thought to be an original) of the Spanish artist's *Christ as the Good Shepherd*. The same painting, then in the Duchess of Bridgwater's collection, may also have influenced Reynolds earlier 'fancy picture' *Shepherd Boy* of 1772. Gainsborough also owned a *St. John the Baptist* (National Gallery, London) which he believed to be by the Sevillian painter. Significantly the paintings which attracted Gainsborough were devotional ones.

Both Gainsborough and Reynolds were capable of transferring the religious sentiment of Murillo's devotional paintings to their own domestic, rural and peculiarly English settings. One need not, therefore, look for comparison only to Murillo's urchin scenes to find similar wistfully sad gazes and the same low-key tonality of dusty browns, greens and silvery greys, for these also appear in his altarpieces. But despite Gainsborough's use of real peasant children and even pigs, which he had brought into his studio for the purpose, he created a much more sanitized version of the poor. Though his cottage girl sits amongst the earth and pigs in torn clothing her discreetly placed bare feet remain remarkably unsullied, unlike the grubby soles of Murillo's urchins thrust towards the spectator. Gainsborough's visions of dreamy melancholic children employed in everyday country activities were particularly successful in his lifetime, fetching much higher prices than his full-length aristocratic portraits. His contemporary and rival in portraiture, Joshua Reynolds, commented on how he had been 'captivated with … the interesting simplicity and elegance of his little ordinary beggar-children' and considered this painting to be 'by far the best picture he ever painted, or perhaps ever will'.[1] His praise came not only in the form of words for he bought the painting in 1782 for his own collection.

Literature:
Ellis Waterhouse, '*Gainsborough's 'Fancy' Pictures*', Burlington Magazine, 1946, vol.88; John Hayes, *Gainsborough: Paintings and Drawings*, 1975; Tate Gallery, *Thomas Gainsborough Exhibition Catalogue*, 1980.

References:
Tate Gallery Catalogue, 1980, p. 42;
Hayes, 1975, No.101

12.
Sir DAVID WILKIE (1785-1841)
The Guerrilla's Departure
93 x 82.4cm
(Her Majesty The Queen)

When David Wilkie began his seven-month visit to Spain in October 1827 he was the first major British artist to see Spanish art over a prolonged period in its native environment. The visit was intended as a convalescence, for his health and his art, and the paintings he produced as a result showed a marked change of style. His colouring became richer and more sombre and he increased his use of varnish to give a deeper hue to his canvases. This painting was the second of a set of four works resulting from his tour and represents Wilkie's most direct quotation from and tribute to Murillo. The central episode in which a Spanish guerrilla requests a light from his confessor before riding off to defend his country against the French, was stimulated by a scene witnessed on the streets of Toledo between a muleteer and a monk. On Wilkie's return to England in 1828 his royal patron, George IV, purchased the Spanish set and commissioned the fourth painting, in which the guerrilla returns wounded, to act as a pendant to this painting. Wilkie regarded the set as a series 'illustrative of the late war', referring to the Spanish Peninsular war of independence in which the British had played a prominent part. For him the painting was more than a quirky gesture, observed, remembered and transposed to canvas. It also signified the collaboration of the people and the Church in the defence of their country. It is all the more interesting that in this carefully contrived work the preliminary drawing for the composition did not include the crouched figure of a boy kneeling in the foreground, whose posture is adapted from Murillo's urchin paintings. The beggar boy was a later consciously introduced coda to the main composition, underlining Wilkie's admiration for the Spaniard with a deliberate ackowledgement of his work. His letters and diary show the high regard that Wilkie had for Murillo's technical facility with paint, the flesh colouring 'tinged with the glow of the sun'.[1]

The comments made after his brief visit to Seville also make clear the awe which Wilkie felt at the acclamation of Murillo's art at all levels of society. It may well be that what Wilkie admired in Murillo was his ability to appeal to the tastes of the people yet paint in the idiom of high art, a synthesis which Wilkie himself sought.

Literature:
Oliver Millar, *The Later Georgian Pictures in the collection of Her Majesty the Queen*, 1969; P.M. Irving, *The Life and Letters of Washington Irving*, 1862; North Carolina Museum of Art, Raleigh, *Sir David Wilkie of Scotland Exhibition Catalogue*, 1987

References:
Alan Cunningham, *Life of Sir David Wilkie*, 1843, vol.II, p.487

13.
JOHN PHILLIP (1817-67)
The Early Career of Murillo, 1634
183 x 254cm
(Forbes Magazine Collection on loan to Aberdeen City Arts Department, Art Gallery & Museums)

This dominating painting is typical of the anecdotal scenes of day-to-day Spanish life which appealed to the mid-Victorian art public. Phillip's earliest successes had been with Scottish genre subjects following in the tradition of his fellow Scotsman, Sir David Wilkie. But after several journeys around Spain he became so well known for his paintings of that country that he was

nicknamed 'Spanish' Phillip. His depiction of Murillo's youthful career, hawking his paintings at the Feria, the weekly fair held in Seville, was based very closely on the account of the artist's life in the *Annals of the Artists of Spain* written by another compatriot, Sir William Stirling-Maxwell. A passage from the *Annals* was quoted in the catalogue of the Royal Academy exhibition when it was shown in 1865: 'He was reduced to earn his daily bread by painting coarse and hasty pictures for the Feria, … the unknown youth stood among the gipsies, muleteers, and mendicant friars, selling for a few reals those productions of his early pencil, for which royal collectors are now ready to contend.' Phillip peopled his canvas with typically Murillesque characters: the gypsy woman with her child modelled from Murillo's 'gypsy' madonnas and cherubs; the still life of fruit and earthenware pots

apparently lifted straight from an urchin painting. The biographical scene which Phillip chose to depict to represent the Spanish artist's career is significant. To Victorian genre painters such as Phillip, Murillo was an exemplar of the artist drawing sustenance from real life and dependent, like them, on popular taste for his living. Nineteenth-century biographers consistently stressed Murillo's poor background, precocious talent and struggle for artistic recognition from the Church and public, unlike the biographers of previous centuries who, wishing to stress the nobility of art, had provided Murillo with a suitably noble family status. Phillip's painting met with great critical acclaim when it was exhibited at the Royal Academy. The critic of the *Art Journal* believed that he had 'seized upon a subject which for national character, local colour and historic truth is not to be surpassed' and had 'outtopped his highest triumph'. But the attitude of the future towards Spanish art was not governed by the success of Phillip's work and his admiration of Murillo but by that of another artist who showed at the 1865 Academy, James McNeill Whistler, and his regard for Velázquez. Within thirty years of *The Early Career* being exhibited it came under criticism from R. A. M. Stevenson, the art critic and biographer of Velázquez. He found its realization of the open air unconvincing and preferred a painting by the Velázquez-influenced Dutch artist, Jozef Israels, but nevertheless he could not deny the flamboyance and robust brushwork of Phillip's Spanish masterpiece.

Literature:
Christopher Forbes, *The Royal Academy (1837-1901) Revisited*, 1975, No. 52.

· BIBLIOGRAPHY ·

For all basic facts about Murillo's life and work I have used the authoritative three-volume biography and catalogue, D. Angulo Iniguez's *Murillo: su vida, su arte, su obra*, 1981 and the admirable Royal Academy exhibition catalogue *Murillo* 1982. Listed below is a select bibliography of material used to write the essay and catalogue.

Books and Periodicals

Memorias de Don Antonio Alcalá Galiano publicado por su hijo, Madrid, 1886, 2 vols.

F. Arana de Valflora, *Compendio Histórico y Descriptivo de la muy noble y muy leal Ciudad de Sevilla*, 1789, Parts I and II

A. Aris, 'Harringay House', *Lost Houses of Harringay*, Hornsey Historical Society, 1988

A. Braham, *El Greco to Goya*, National Gallery, exhibition catalogue, 1981

J. Brown, *Murillo and his drawings*, Art Museum, Princeton University, exhibition catalogue, 1976

W. Buchanan, *Memoirs of Painting*, London, 1824, 2 vols.

Ceán Bermúdez, *Diccionario Histórico de los más ilustres profesores de las Bellas Artes en España*, 1800

J. Colon y Colon, *Sevilla Artistica*, 1814

R. Cumberland, *Anecdotes of Eminent Painters in Spain*, 1782

A. Dominguez Ortiz, *Historia de Sevilla en el siglo XVII*, 1983

F.H. Dudden, *The Life and Times of St. Ambrose*, Oxford, 1935

R. Ford, *A Handbook for Travellers in Spain*, 1847 (1st ed. 1845)

ForA. Franco Silva, *Los esclavos de Sevilla*, 1980

R. Gatty, *Portrait of a merchant prince: James Morrison*, 1977

F. Gonzalez de Leon, *Noticia Artistica y Curiosa de ... Sevilla*, 1844

J. Guerrero Lovillo, 'La pintura sevillana en el siglo XVIII', *Archivo Hispalense*, 1955, no.69

M. Haraszti-Takács, *Murillo*, Budapest, 1982

E. Harris, 'Prints after Velázquez and Murillo in nineteenth- century Britain', *Journal of the Warburg and Courtauld Institutes*, 1987, vol.50. pp.148-159.

I. Hempel Lipschutz, *Spanish Painting and the French Romantics*, Cambridge, Mass., 1972

A. Jameson, *Legends of the Madonna*, 1852

D.T. Kinkead, *Juan de Valdés Leal (1622-1690): His life and work*, New York, Garland, 1978; 'The Altarpiece of the Life of St. Ambrose by Juan de Valdés Leal', *The Art Bulletin*, LXIV, 1982, pp.472-81

J.B-P. Lebrun, *Choix de tableaux récueillie dans l'Espagne et Italie dans 1807 et 1808, 1810*

L.F.Lejeune, *Memoires*, Paris, 1895

Juan de Loaysa, *Pésame á la iglesia de Sevilla, en la reciente muerte de ... Senor D. Ambrosio Spínola y Guzmán ...*, Seville, 1684

E. Mâle, *L'Art Religieux aprés le Concile de Trente*, 1932

N. Ayala Mallory, *Bartolomé Esteban Murillo*, Madrid, 1983; 'Painting in Seville 1650-1700', *Painting in Spain 1650-1700*, Princeton Univ. exhibition catalogue, 1982

F. Mercey, 'La Galerie du Marechal Soult', *Revue de deux mondes*, Paris, 1852

J.A. Morgado, *Prelados Sevillanos*, Seville, 1899 & 1904

A. Muro Orejón, *Apuntes para la historiá de la Academiá de Bellas Artes de Sevilla*, 1961

National Art-Collection Fund Annual Report, 1953

D. Ortiz de Zuñiga, *Anales eclesiasticos y seculares de Sevilla desde 1246 hasta 1671*, Sevillle, 1677; extended up to 1700 by A. M. Espinosa y Carzel, 1775

F. Pacheco, *Arte de la Pintura*, 1649, ed. F.J. Sánchez Canton, 1956

A. Palomino, *Lives of the Eminent Spanish Painters and Sculptors*, 1724, ed. N. Ayala Mallory, 1987

L. Parris, *The Loyd Collection of Paintings and Drawings*, London, 1967

E.A. Peters, *Mother of Carmel: A Portrait of St. Teresa of Jesus*, 1945

R.M. Perales Piqueres, *Juan de Espinal*, 1981

M.E. Perry, *Crime and Society in Early Modern Seville*, 1980

A. Ponz, *Viage de España*, 1772-94

G. Redford, *Descriptive Catalogue of the Pictures at Lockinge House*, 1875

J. Romero y Murube, *Francisco de Bruna y Ahumada*, 1965

Marques de Saltillo, *M. Frederic Quilliet, Comisario de Bellas Artes del Gobierno Intruso 1809-1814*, Madrid, 1933

M. Santos García Felguera, *Murillo y su Fortuna*, 1989

W. Stirling-Maxwell, *Annals of the Artists of Spain*, 1848; *Essay towards a catalogue of prints engraved from the works of Velázquez and Murillo*, London, 1873

M. Trens, *María, Iconografía de la Virgen en el arte espanol*, Madrid, 1947

E. Valdivieso, *Valdés Leal*, Seville, 1988

J. Velázquez y Sanchez, *Anales de Sevilla*, Seville, 1872

M. Volk, 'New Light on a Seventeenth-Century Collector: the Marquis of Leganés', *The Art Bulletin*, 1980, vol.62 no.2, pp.56- 68

M. Warner, *Alone of all her sex: the myth and the cult of the Virgin Mary*, 1976

E.K. Waterhouse, 'The exhibition from Althorp House at Messrs Agnews', *Burlington Magazine*, vol.89, 1947, pp.77-8

W.T. Whitley, *Art in England 1800-1820*, Cambridge, 1928; *Art in England 1821-1837*, 1930

Manuscripts

Will of Ambrosio Ignacio Spínola y Guzmán, Seville, Archivo de Protocolos, 22 December 1679, Oficio 24, fols. 535-43

Will of Edward Gray, London, P.R.O., 31 October 1838, PROB 11/1901, fols. 347-51

List of paintings in Edward Gray's collection sent to James Morrison, undated about 1838, private archives

· LIST OF ILLUSTRATIONS ·